WATERCOLOR FOR THE *fun* OF IT
Painting Greeting Cards

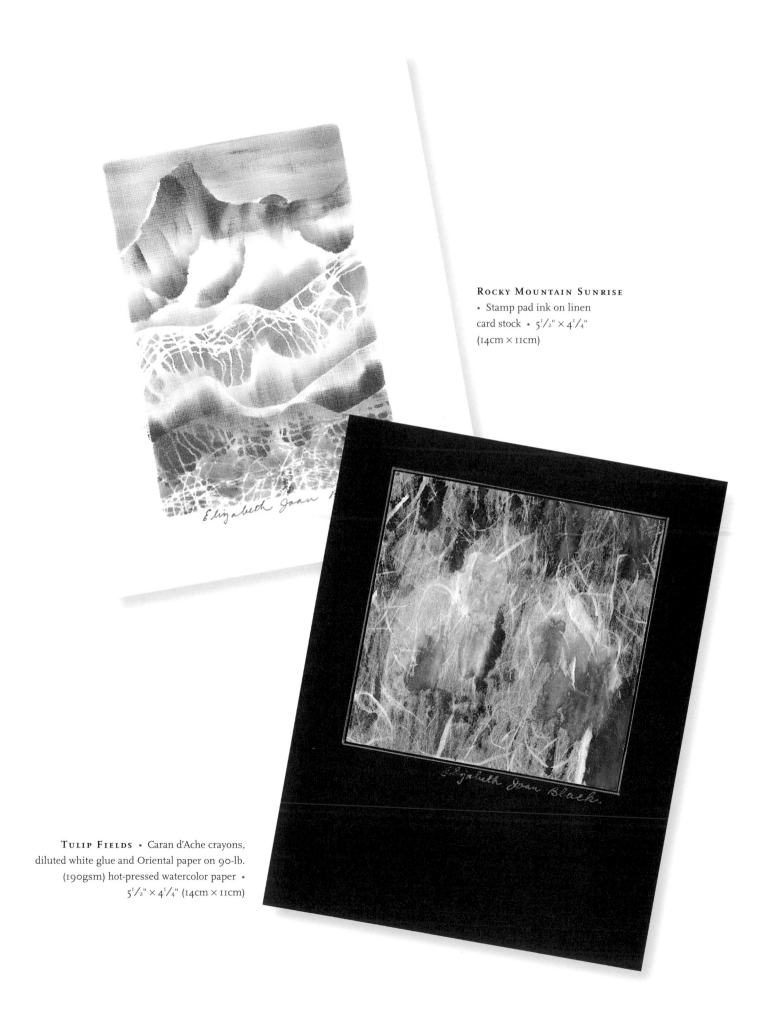

ROCKY MOUNTAIN SUNRISE
• Stamp pad ink on linen card stock • $5^{1}/_{2}$" × $4^{1}/_{4}$" (14cm × 11cm)

TULIP FIELDS • Caran d'Ache crayons, diluted white glue and Oriental paper on 90-lb. (190gsm) hot-pressed watercolor paper • $5^{1}/_{2}$" × $4^{1}/_{4}$" (14cm × 11cm)

WATERCOLOR FOR THE *fun* OF IT

Painting Greeting Cards

Elizabeth Joan Black

NORTH LIGHT BOOKS
CINCINNATI, OHIO
www.artistsnetwork.com

About the Author

Elizabeth Joan Black was born in Alberta during the "Hungry Thirties." She grew up on a farm, and as a shy, only child, walked to the first grade in a country school where the highlight of her day was weaving pre-cut paper mats. She envied her friend Sigfried who rode his pony "Daisy" to school. Joan's dreams of having her own pony materialized when her parents moved and the new country school was two and a half miles away. Billy, a cunning Shetland pony, retired from coal mine work, became the focus of Joan's early life.

Joan eventually became an elementary school teacher, but only after 1963 did she become actively involved in the visual art scene. She has taught classes in creating greeting cards for community organizations, seniors' centers and the local community college in Thunder Bay. She has been on the staff of the Haliburton School of the Arts in Haliburton, Ontario, Canada since 1990. She continues to explore new media and experiment with art materials. Joan resides in Thunder Bay with her husband, Jake, and Cally, the vacationing cat.

Other fine North Light Books are available from your local bookstore, art supply store or direct from the publisher.

06 05 04 03 02 5 4 3 2 1

Library of Congress Cataloging-in-Publication Data

Black, Elizabeth Joan
 Watercolor for the fun of it: painting greeting cards/Elizabeth Joan Black.
 p. cm.
 Includes index.
 ISBN 1-58180-193-9 (alk. paper)
 1. Watercolor painting--Technique. 2. Greeting Cards. I. Title.
Nd2420 .B53 2002
751.42'2--dc21

Editors: Mike Berger and Bethe Ferguson
Cover and Interior Designer: Wendy Dunning
Interior Production Artist: Kathy Bergstrom
Production Coordinator: John Peavler

METRIC CONVERSION CHART

to convert	to	multiply by
Inches	Centimeters	2.54
Centimeters	Inches	0.4
Feet	Centimeters	30.5
Centimeters	Feet	0.03
Yards	Meters	0.9
Meters	Yards	1.1
Sq. Inches	Sq. Centimeters	6.45
Sq. Centimeters	Sq. Inches	0.16
Sq. Feet	Sq. Meters	0.09
Sq. Meters	Sq. Feet	10.8
Sq. Yards	Sq. Meters	0.8
Sq. Meters	Sq. Yards	1.2
Pounds	Kilograms	0.45
Kilograms	Pounds	2.2
Ounces	Grams	28.3
Grams	Ounces	0.035

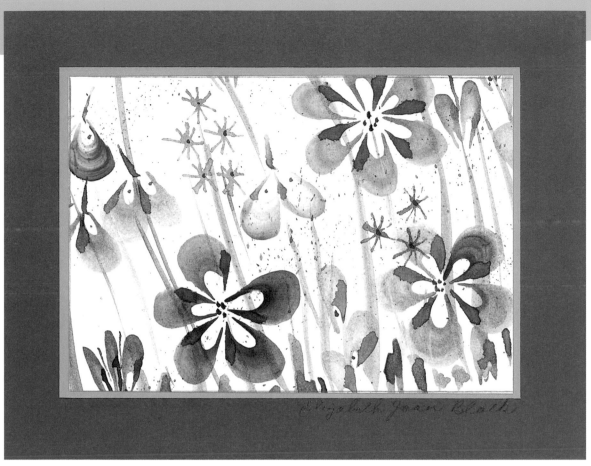

FLOWERS IN THE WIND • Watercolor on typing paper • 4¹/₄" × 5¹/₂" (11cm × 14cm)

Dedication

To my students, friends and family who have shared their insights and inspirations with me, and to the memory of my parents who encouraged my interest in the arts.

Acknowledgments

I wish to thank my husband, studio potter Jake Black, for all his faithful help with photography, advice, proofreading and technical assistance all the while living in a house that threatened to explode with paper files. As well I am indebted to my calligraphy teacher, Doris Arnold, and the Quetico Quills for sharing with me the joy of card designing. To my colleagues at the Haliburton School of Art for expanding my horizons, in particular calligrapher Lois Sander, who teaches with me, and watercolor artist Gordon MacKenzie, whose words of confidence and challenge caused this book to be undertaken. Thank you as well to my editors Pam Wissman, Bethe Ferguson, Nancy Lytle and Mike Berger for their interest and support.

Cover art by Elizabeth Joan Black, Doris Arnold and Sherri Caswell.

Table *of* Contents

1) making a magical MARKER LANDSCAPE

Relax and let watercolor markers and water work their magic for you. Compose fanciful landscapes and watch how salt can add a splash of whimsy to your cards. You will also learn how to create delicate flower forms with cottons swabs dipped in water or weak bleach solution.

2) label it FUN

Now you can forget about the trials of gluing, and enjoy decorating self-adhesive labels with markers, metallic pens and watercolors. Cut up the labels and arrange them in pleasing grids, crazy quilts and other imaginative ways!

3) wrap up COLOR

Discover how using wrinkled plastic wrap over your wet paint is just the starting point to create a wealth of delightful card possibilities. Find out how to establish focal points in your work. Learn how to use viewfinders to capture pleasing compositions in your watercolor piece. Experiment with torn and cut edges, and fine-tune your gluing and mounting skills to showcase your painting to its best advantage.

4) MINISCAPES capture the moment

Discover the joys of working small! Take the pressure off as you experiment on a smaller scale. Let the water and paint surprise you with spontaneous happenings as you boldly dash in color! Develop your sense of design as you assess each miniscape.

5) stunning STENCILS

All around you are materials you can use as stencils to create amazing designs—cheesecloth, lace, mesh vegetable bags and leaves just to name a few.

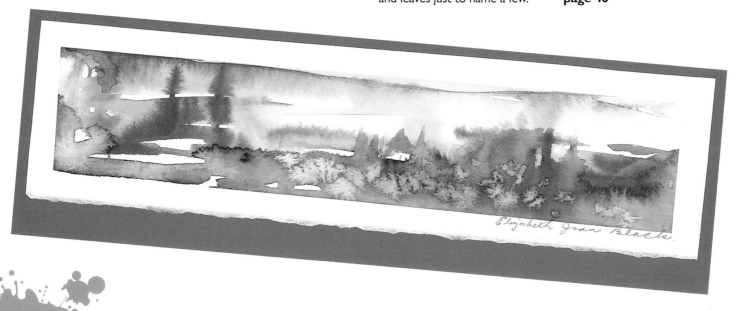

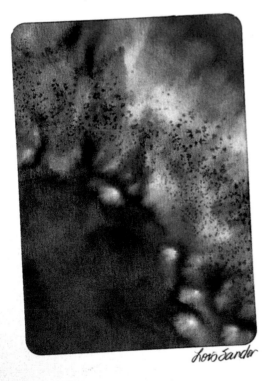

Lois Sander

Introduction

Dear Reader,

For nearly half a century the joy of my life was music, and it's still important to me. However when I was forty-eight I damaged my hearing with high-pitched sounds and developed hyperacusis, which is acute sound sensitivity. My music world was no more so I turned to calligraphy, the quietest creative process I could find. When I recovered to a level where I could teach classes, my beginning calligraphy students requested that I expand the short card demonstrations I gave at coffee time to a full blown course. ❺ Thus my adventure into teaching card-making was born. I truly believe in the saying that "When God closes a door, He opens a window." For me that window was sharing with others the joy of creating greeting cards, a passion that has changed and enriched my life beyond measure and still continues to do so. ❺ It is my hope that this book will encourage you to plunge into the fun of creating your own unique greeting cards and sharing them with others. As one of my senior students said to me "Making cards is a blessing!" May it be so for you.

Elizabeth Joan Black

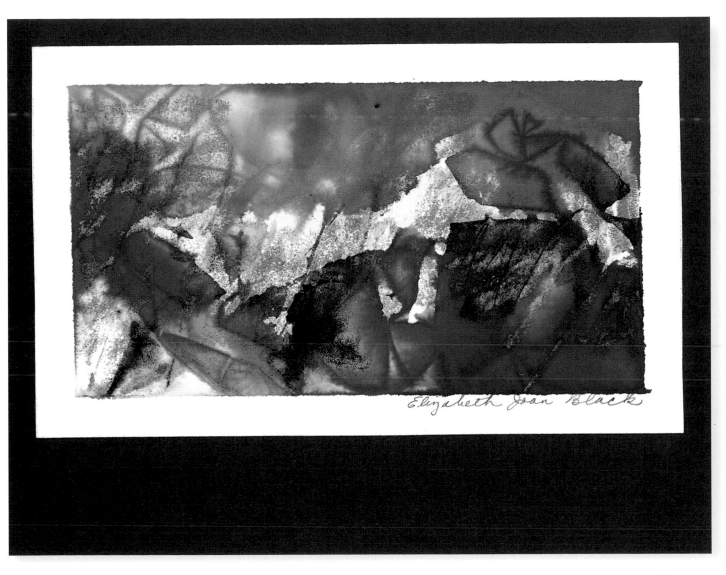

SLICE OF BLUE • Wax crayon, liquid watercolor and plastic wrap on 90-lb. (190gsm) hot-pressed watercolor paper •
4$\frac{1}{4}$" × 5$\frac{1}{2}$" (11cm × 14cm)

A Quick Start Guide

Atomizer spray bottle for water or paint which creates a fine mist when pumped or squeezed

Border Guides small mats used for framing pictures that indicate where a border should be outlined. You can draw a delicate, accurate border by tracing around the inside of the border guide with a fine pen.

Border Masking Frame a paper frame which is placed on top of your card to mask off the border area while you create your composition

Calligraphy the art of beautiful writing

Caran d'Ache Crayons water soluble crayons whose marks can be blended with a wet brush

Cool Colors blue, green and purple; the colors selected to interpret a cold mood

Composition the pleasing arrangement you decide on in your art by using the principle of good design to organize the elements of design

Cotton Linter long, fibered, all-rag paper product which can be soaked, blended and formed into handmade paper

Couching (Pronounced "kootching") a paper-making term which refers to taking your freshly made sheet of paper, still on the screen, laying it down onto the smooth cloth-covered surface and pressing out the excess water with a sponge to meld the fibers together.

Deckle and Screen in papermaking, the two-part frame which is used for catching the fibers to make a sheet of handmade paper

Dominant Color the color most prevalent in a composition

Flourishes flowing lines used to enhance your composition; often made with the strokes of a pen or the swish of a sponge

Focal Point the part of an artistic composition that first attracts the eye of the viewer; sometimes this is called the center of interest

Foreground the part of a landscape which would be closest to the viewer in real life; usually found at the bottom area of the composition

Gouache opaque watercolor much like poster paint

Off-cuts leftover paper from commercial printing jobs

Pointillist painting technique that uses tiny dots of color placed close together so they seem to blend together when viewed from a distance

Primary Colors red, yellow and blue; the colors from which all other colors can be mixed

Resist a substance that, wherever it is applied, prevents paint from adhering to the surface of paper

Serendipity the act of making fortunate discoveries in your creative endeavors which are quite unexpected and appear spontaneously

Squeegee a piece of stiff plastic used to scrape and move paint

Sumi-e Paper lightweight, white absorbent art paper often used for Oriental brush painting. In the techniques in this book coffee filters are a good substitute.

Undermat a piece of paper mounted underneath a painting that protrudes slightly beyond the composition to give a very narrow border

Viewfinder a matboard frame that you can move over your painting in order to select a pleasing composition for mounting

Warm Colors yellow, red, orange; the colors associated with creating a mood of warmth

Wash paint, diluted with water, that yields a light suggestion of color

It's time top get started on a grand adventure! In the next few pages I will discuss some basic information you will need to begin including: basic materials, how to use borders in your work and elements of good composition and great design.

This book covers a variety of water-based media so refer to the materials list at the beginning of each project for the particular supplies you'll need for each technique. Basic papers for cards and envelopes and some basic art supplies are needed for all the cards, so let's consider them first.

Card Stock Weight and Finish

I like to keep a good amount of basic card stock paper on hand so that I can try out many ideas without worrying about running out of supplies. You might like to have several stacks of bright white, off-white and cream for your basic cards. For mounting miniscapes and prints it's especially useful to have stock in burgundy, dark forest green, and a medium clear blue, as these seem to complement many color schemes. But by no means limit yourself to these colors. Sometimes a bright red, black or navy will be just the background your card needs to make it sing! If you would like to write inside the dark cards, you'll first need to glue a liner of light-colored paper to write on. Cut your liners to 8" × 5" (20cm × 13cm), so that they fit nicely inside the card and won't overlap the edges.

What to Look for in Card Stock

⊚ Try to find 80-lb. (175gsm) weight cover card stock that will stand up crisply when folded once. Sixty-five-pound (140gsm) cover stock is just barely heavy enough to keep its shape, especially if you mount watercolor or prints on it. Be economical and choose standard sizes of paper. I use 8½" × 5½" (22cm × 14cm) paper, half of a standard sheet, which folds once to fit in a regular invitation-size envelope. If you

fold the paper lengthwise to make a long narrow card, the card will fit into a business size no. 10 envelope.

- Cover stock may come from printer's "off-cuts" or leftovers. Buy packages of $8^{1}/_{2}" \times 11"$ (22cm × 28cm) paper and cut it in half, or large sheets of printing paper, which your printer can order and cut into about sixteen cards per sheet. The printer may charge a fee for cutting, but I feel it's worth it to have the paper ready and accurately cut. Ask to see paper sample books at the print shop to see what is available in different colors and surface textures— such as linen, laid and felt.

- Invitation-size envelopes (often referred to as A-2) which are $4^{1}/_{2}" \times 5^{7}/_{8}"$ (11cm × 15cm) are available at your printer or in business supply stores in boxes of five hundred or less. These envelopes are usually all white. Store your envelopes in a dry place or they will stick shut.

- Choose a few sheets of light-weight colored bond copy paper to cut up for under-mats for mounting your compositions.

- Ask your paper supplier to save cover weight off-cuts for you and then be sure to pick them up! These leftover pieces are great to use for enclosure cards, bookmarks, making stencils, unusually shaped cards and for trying out new ideas. Sometimes card shops sell odd sizes of leftover envelopes at reduced prices.

- If you wish to have matching cards and envelopes, paper specialty shops carry them, but their cost makes them more inhibiting to work with.

Choose Your Basic Art Supplies

These materials are useful for most activities. Check the individual materials lists for each technique for specific items before going shopping. Throughout the book I will mention many brands of specific supplies I prefer to use, but feel free to use whatever brand you choose.

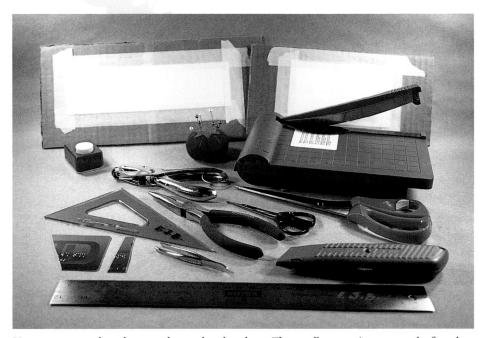

Here are some tools and set-ups that are handy to have. The small paper trimmer may be found at office supply stores and is sometimes sold along with scrapbooking supplies. Panels of cardboard are useful for securing miniscapes. The large piece of credit card is for folding paper. The small piece is a squeegee for moving paint around on a surface.

Border guides are essentially small picture mats and can easily be cut by a framer for several dollars apiece. If you can afford just one, I think the $^{3}/_{4}$-inch (1.9cm) border is the most useful.

- Scissors
- Ruler (steel edged is preferable)
- Sharp HB pencil for naming and signing your cards
- Paper trimmer (craft knife and straight-edge will work too)
- 6-inch (54cm) right-angled square (metal or plastic) for squaring up edges

Border Guides

Border guides serve as windows or viewfinders when choosing which part of your art to mount. The outside measurement of the border guide should be $5^{1}/_{2}" \times 4^{1}/_{4}"$ (14cm × 11cm) which is the front of the standard card I use. I have a commercial framer cut several guides for me, one is a window with a $^{3}/_{4}$-inch (1.9cm) border, another is a window with a $^{5}/_{8}$-inch (1.6cm) border and

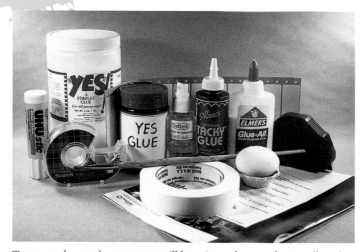

Test your glue on the paper you will be using to be sure that it will work.

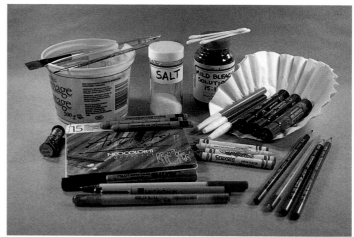

Here is your dual-purpose water jar and brush holder. Caran d'Ache crayons can be purchased in various sized boxes and sometimes separately.

the third is a window which is 3-inch (8cm) square with ⅝-inch (1.5cm) borders on three sides as shown. You might also like a window which is 3" x 2½" (8cm × 6cm) with ⅝-inch (1.6cm) borders on three sides. If you do not have access to a framer, you can measure and cut these guides yourself from heavy card. You can also use two L-shaped borders as a viewfinder.

Choose Your Glues

The most versatile glue I have found for mounting art is YES glue. It comes in a life-time supply—about 2½ lbs. (1.1kg) in a big jar, and is found only at large art supply stores. (They also have smaller sizes, but I like to buy the larger size and store the extra.) YES glue lasts for several years if it's kept closed and clean. Spoon out some glue into a smaller bottle for everyday use. Spray it with a tiny bit of water to make it spreadable. Made for mounting art, it does not buckle paper and holds well. If you cannot find YES glue, a tacky craft glue such as Aleene's Tacky glue may be used for mounting. A dry liner applicator with a permanent cartridge is handy and clean if you don't like spreading glue. Just be sure to run it in a straight line or it will tangle the glue tape. Double-sided

tape also works for mounting watercolors and prints.

Glue sticks and adhesive labels are other options, and egg glue made from egg yolk mixed with water is great for putting down collage and giving a shiny surface. Be sure to store your egg glue in the refrigerator. You can use acrylic matte medium as a glue, and add a slight sheen to your work.

How Do You Glue?

- Use old magazines with shiny pages as a gluing area. Turn over a fresh page every time you start to glue again.
- Place a piece of waxed paper over your card, then press with your hands to set the glue and fix your art in place.
- Wrap your card in waxed paper or plastic wrap before you put it under a pile of books to press it.
- Before a card leaves your hands, check the glue job and be sure it's secure.
- If you get a smudge of glue on your card, try gently wiping it with a damp cloth to remove it.

Choose Your Art Papers

Good quality paper is worth the money you spend on it. I like 90-lb. (190gsm) Arches

hot-pressed paper (or cold-pressed) and buy it in the big 22½" × 30" (57cm × 76cm) sheets. Whatever brand you choose, try to select all-rag content, handmade watercolor paper. Sometimes 90-lb. (190gsm) paper is hard to locate. 140-lb. (300gsm) is much more commonly found and may be used, but since it's heavier, it is more expensive and a bit more difficult to mount without warping the card.

Choose Your Brush and Your Colors

A ½-inch (13mm) brush—I recommend Aquarelle—is the only watercolor brush you will need to make the cards in this book (beyond a tiny detail brush for occasional use). Invest in a good ½-inch (13mm) brush with synthetic bristles that are no longer than ⅝-inch (1.6cm). Be sure it will naturally come to a sharp chisel edge. You can make a special holder for it by cutting two notches out of a plastic cottage cheese or a large yogurt container you use for water; this will allow you to rinse your brush and immediately lay it flat to dry in the notches of your water container. Leaving your brush standing on its bristles in water is the surest way to ruin it. When it's dry, you can put it back into your "pocket holder" or a jar with

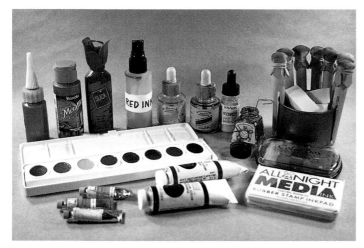

Liquid watercolors in dropper bottles are hard to find except at large art supply stores. Food coloring will yield a softer result.

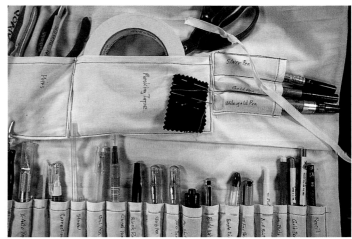

This is a corner of my "pocket" holder for card supplies. I also made a cloth bag to enclose it so that it's easy to take to workshops.

the bristles up. If the bristles on your brush do get bent out of shape, wash it well, work some bar soap into the bristles, shape it to a sharp chisel with your fingers and let it dry.

You'll find that a student set of eight watercolors in pans will enable you to do most techniques. Of course professional watercolors in tubes are preferred but they are more expensive. If you do buy tube watercolors, start with the primary colors which will give you lovely blends. Consider a blue-red such as Permanent Rose, a clear yellow such as Winsor Yellow, a dark blue such as Ultramarine, a lighter blue such as Cerulean and Burnt Sienna for an earth tone. Refer to watercolor books for ideas. Be daring and experiment with colors that speak to you!

Create Storage for Your Materials

Having your tools and supplies in an orderly state will enhance your creative abilities. Some ideas for storage include:

- Stitched "pocket" holder for pens, brushes and other supplies made from a double cloth panel, shaped like a pillow case, with one long side open. On one side, stitch pockets to hold tools, slide stiff cardboard inside the panel and clamp the open top

side shut with bulldog clamps. Let it stand at the edge of your table and lean against the wall.
- Containers to hold pencils, crayons and water. If you have a decorative holder, by all means use it.
- Rolling plastic storage drawers for paints and other supplies.
- Plastic boxes for storing paper out of the light to prevent it from fading and damage.

Set Up a Recycling Bin

Tape a plastic bag to the edge of your work area so that you can save scraps of paper that are too interesting to throw away and cards that need more work on them. If you have cards that don't yet sing as you'd like, try adding layers of Oriental paper, pen lines, stamping designs, fabric paint, beads, feathers, embossing powders or more paint. I like to call these my "anything goes" series.

Set Up a Display Area

It's important to display your work and view it from a distance. Try some magnets on the refrigerator door, a high shelf or bulletin board. If you have to use pins to display your work, push them in next to your work at an angle so that you do not scar your card. Ask

your family and friends for comments. Children will often give you the most insightful opinions.

Add Words to Your Work

- Do your lettering of greetings for the outside of your card (for instance Happy Birthday) on a separate panel of paper and mount the panel when you are happy with all parts of your card.
- If you intend to have your lettering follow a horizontal line then be sure that it does! Draw faint guidelines using your right-angle triangle to make sure your writing is level.
- Give your card the honor of a title and sign all your cards. I do not put a date on my cards. If you are selling your cards customers seem to want new cards, but the decision is up to you.

Always Keep Good Composition in Mind

In each chapter you will find reminders about design. However, there are some basic thoughts you should bear in mind each time you begin to create a card:

- Stay out of the corners! If you have lines shooting out of corners or other elements

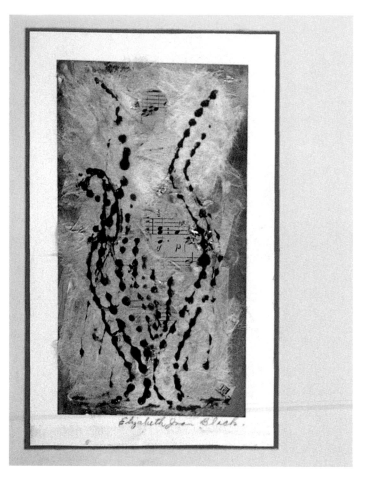

Ton-y-Botel

This piece started out as a miniscape that was not satisfying, so I filed it for "anything goes." I began by adding some Oriental paper to the middle of the piece, then some music copy I had aged by soaking it in tea. Around this I placed some pieces of gold doily. I softened the gold by putting more Oriental paper over it and then added a grid of yellow slick fabric paint (waterproof, liquid plastic paint). The yellow was too harsh so I moved it around with a squeegee and softened it with more Oriental paper. The piece needed some definition. Since it was about music I tried a treble clef with slick blue fabric paint. The treble clef looked awkward and isolated so I hid it with some curving blue lines and the piece looked like it was turning into a jug with the treble clef making the handle! A stroke of fortune! It seemed to need a bright accent to give it life so I added dots of red. It suddenly occurred to me what the piece should be called. Years ago as a teenager when I sang in a church choir we learned a powerful Welsh hymn called Ton-y-Botel. Our director told us that the title meant "Tune in a Bottle" and that the melody had been rescued from the sea as it floated to shore in a bottle. I was always intrigued by this tale and fifty years later it has emerged again in my life as this card.

that direct attention to the corners of your work, the viewer's eye will be led right out of the composition.

⦿ Create a focal point that will attract your viewer's eye to an area near the middle of your composition. The focal point is often the brightest place, the place where your lightest and darkest colors meet or a place of contrast that draws the attention of the viewer. The focal point will appear more graceful and less formal if it's somewhat off-center so that your eye can enjoy the journey of finding it.

⦿ Plain borders bring your card to life. While spots in the outer edges will pull your eyes off the composition, a continuous border will enhance the main message and hold the composition together. Your safest bet is to use a border that is the same width all around.

⦿ A border that is wider at the bottom of the card gives a graceful lift and visual strength to your composition.

⦿ If you are mounting a small composition on your card, consider arranging your art so that two borders at least are the same width (i.e. top and one side) and the remaining two are noticeably different.

Review the Elements of Design

Probably every book you read will have a slightly different approach to design. However, a very basic list of these elements would include the dot, line, shape, texture, value and color. When you are designing your card consider how the elements of design work together. Ask yourself:

⦿ Would well-placed dots add liveliness to my work?

⦿ Would lines help to connect the different parts of my card? Should I use restful horizontal lines, uplifting vertical lines or energetic diagonal lines to get my ideas across?

⦿ Are the shapes in my card varied and pleasing?

⦿ When I squint and look at my card, do the light and dark values work effectively?

⦿ Should I use real texture that you can feel or smooth simulated texture?

⦿ Which colors would create the mood I wish to convey?

Review the Principles of Design

Every artist will have a slightly different list of the principles of design, so be sure to read other references to add to your understanding of good design. Always keep these

You can often bring your composition to life by using a very narrow undermatting of paper that picks up a color in the artwork. However, if the undermatting is too dark or too wide (more than about ¹⁄₁₆ of an inch [2mm]), it can easily overwhelm the art. I recall a framer saying that the frame should be no darker than the darkest part of the picture. This is a good maxim to remember when you are undermatting your art.

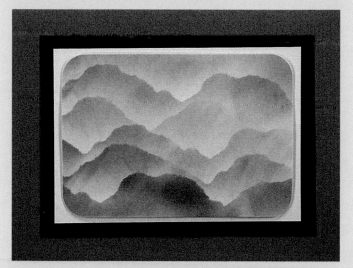

Susan first mounted her piece entitled *Mountain Passage* on a white undermat with a very dark navy blue second undermat. The navy mat was too wide and darker than anything in her composition. This drew attention to the frame, not the art. There was another factor that drew our attention away from the soft mountains: the bright white arrow shapes that were formed by the rounded corners contrasting against the top undermat. Rounded corners are fine for photos in scrapbooking but they can lead to problems in card mountings.

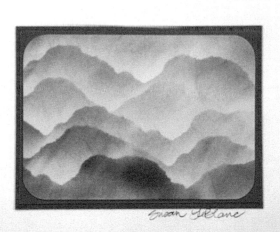

To cut the art back to a rectangle would have made the piece much smaller, so Susan calmed down the corners by using a very narrow purple undermat which was closer to the intensity in her composition than the contrasting white. She chose a second undermat of smoky blue to pick up the colors in her art. White seemed the best choice for the card itself. Can you see how Susan softened the mood of her card by her new choices of undermatting? Now the misty valleys catch our attention as we look at her card and we can enjoy what Susan is showing us without being distracted by the mounting.

principles in mind when you are designing your cards. Here is a very basic list:

- Pattern—remember the eye loves to enjoy repeated elements, such as lines, shapes, textures, values and colors.
- Unity—your card should give the impression of a unified whole. Unify your design by overlapping shapes, connecting lines and repeating elements like colors or shapes.
- Balance—keep working on your design if it looks lopsided or seems to be tipping over.
- Variety—vary the elements in your composition to give it interest. For instance, like the Three Bears, have small, medium and large shapes in your design.

- Focal point—place the most exciting part of your design just off-center so that your viewer's eye will be led to enjoy your whole composition gradually.

Look for Good Design All Around You

When you go shopping, take a moment to look at commercial cards and analyze why you like particular ones. Take every opportunity you can to visit art galleries, museums and art shows to enjoy the work of other artists—past and present. Look at the world of nature with new eyes! Ask viewers how you can improve your work. Be bold! Do something! If it doesn't work, then you have learned more than if it does! Take courses in design and other art media.

Let Your Card-Making Enrich Your Life

Learn something new every day and make a card to celebrate it. Make cards as a journal of your artistic journey. Look for words that will enhance your art. Collect interesting sayings of your young friends. Collect maxims of your old friends. Write some haiku poetry. Most of all have the fun of accomplishing something that is truly your own and of sharing it with the world around you!

making a magical
MARKER LANDSCAPE

Get in touch with your inner child and see how this playful activity will really open up the amazing world of watercolor! Borrow your child's set of markers or browse in the children's department for your very own set in order to play with "pigments plus." Most black, brown and dark blue water-based markers when applied to absorbent paper, then wetted with a brush or cotton swab, will separate into different colors. Taking advantage of this quality can lead to many exciting effects. Many brands will work, but the ones I like best are the Mr. Sketch scented markers, the ones in the all-color pens. Note: permanent markers or the washable Mr. Sketch with white tops are not suitable for this activity.

[MATERIALS LIST]

- Mr. Sketch scented markers in a range of colors (black, brown and dark blue are most useful)
- Absorbent paper such as large round coffee filters or Oriental drawing paper (like sumi-e paper in pads or rolls). Cut your paper into pieces suitable for your card size; about 4" × 6" (10cm × 15cm) is good for most cards and gives you some leeway in mounting.
- Water and a brush (your ½-inch [13mm] chisel brush is fine)
- A ¼ cup (60ml) or so of a weak chlorine bleach solution—mix 15 parts water to 1 part bleach
- Cotton swabs to apply bleach solution
- Pad of folded newspapers
- Coarse pickling or table salt
- Gel pen or a pencil for marking edges
- Viewfinders (windows cut out of stiff card) to help you pick out the most interesting parts of your painting to mount. Use your ¾-inch (1.9cm) or ⅝-inch (1.6cm) border guides and possibly a 3-inch (8cm) square window along with some smaller rectangular windows.
- Paper trimmer or sharp knife and steel edged ruler to trim your edges
- Glue stick for mounting
- Atomizer

1 | Begin with the Sky
With your dark blue marker scribble in the sky, leaving some white spaces to form clouds.

2 | Work to Warm
You can choose whatever colors you would like to create the mountains and land, but use warm colors—pink, orange or yellow—for the foreground. Add some vertical tree shapes to give a contrast of direction. I scribbled in the mountain shapes with purple and used brown and green for the land.

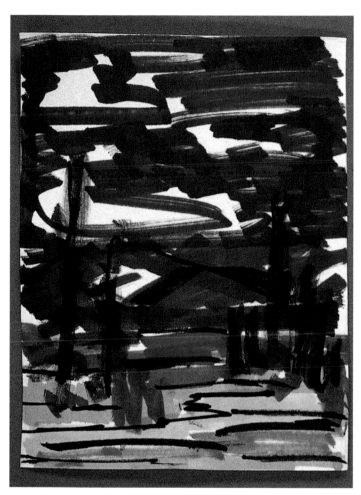

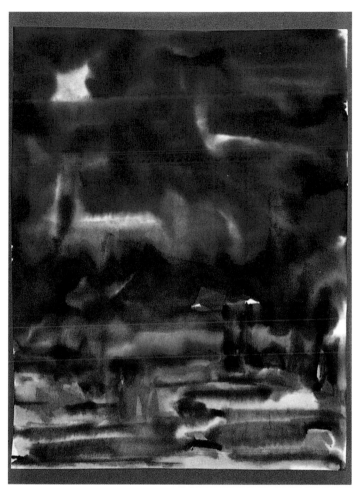

Break Up the Color

3 | Black, dark blue and dark brown will usually break up into several colors. Add drama with some black lines to the colors that will not break up, especially in the foreground.

Water Works

4 | Using your chisel brush, apply water over the whole sky, then wet along the horizon. With the narrow edge of your brush, paint over the black lines you added in the foreground. Add interest and contrast to the fluid look of your card by leaving some dry areas of color. Set your piece aside to dry.

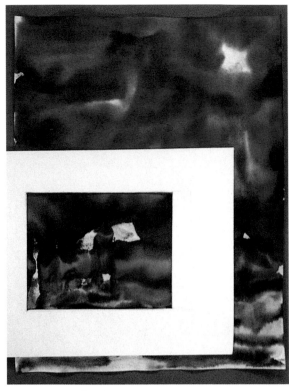

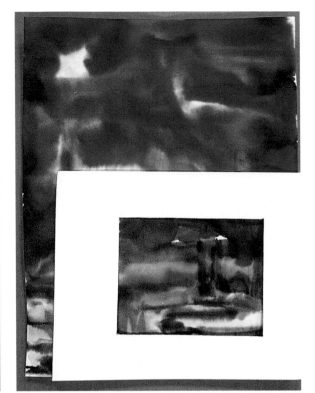

5 | Hunting for Compositions

Run several sizes of viewfinders over your piece to find the parts that you would like to mount. Look at both the back and front of your piece, because the art will be slightly different. A gel pen works well to mark your edges. Trim and square your composition on the paper trimmer. You may need to slide some card stock in with your art when cutting, as the absorbent paper may tear in the cutter.

6 | Intensify Your Colors

Try your piece on a bright white card stock or mat. It usually needs a clean, white background to enhance the intense colors of the markers, but you may find your piece looks pleasing on a different colored background. Be open to trying other ideas. In this piece I saw kite flyers and the kite that got away in the sky. Once I added the sky panel, the card seemed to need more of an earth area. Look at your card and see what it is telling you.

A Skyful of Salt Comets

1 | Fill Your Page with Scribbles
Fill your whole sheet of paper with areas of intense colors, being sure to include some scribbles of black, dark blue and brown.

2 | Sprinkle on the Salt
Use your brush or atomizer to wet the paper. Sprinkle on a few grains of coarse pickling salt and table salt, spread them gently. Spray once more with your atomizer so that the colors are quite wet. Set aside to dry.

3 | Here Comes the Comets
After your paper is dry, you will see a sky full of comets.

4 | An Interesting View
Look at both the back and front of your paper. Choose the most interesting parts to mount.

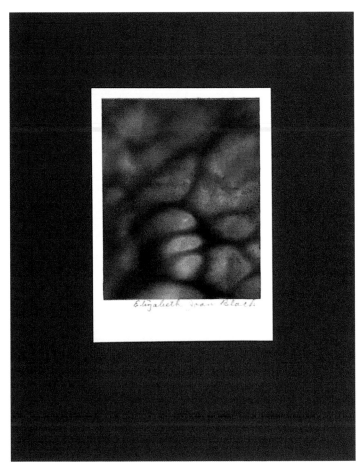

An Indoor Flower Garden

1 **Dot to Dot**
Make dots of your favorite flower colors close together on your absorbent paper. Be sure to use some black, dark blue and brown to give zest to your work. Add contrasting circles or petals around the dots.

2 **Watch Your Flowers Grow**
Now dip a cotton swab into water and hold it still in the middle of a dot and wait. Watch the water spread to form the petals as it works out to the edge of the dot. Be patient, let your flower grow on its own. Rubbing your flower may tear the paper.

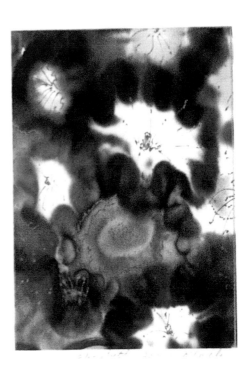

3 **Flower Flourishes**
Try forming the flower petals with your weak bleach solution (15 parts water to 1 part bleach). As you hold the cotton swab in the center of a dot, your flower will grow before you with a striking white throat. Be sure your flowers grow into a crowded mass of blooms—this will keep them from appearing to float in space. Let your flowers dry. Add the finishing touches with suggestions of stamens and pistils using a metallic pen before you decide on how to mount your piece. Use your viewfinders to find the best parts.

4 **Stop and Enjoy the Flowers**
A glue stick works well for mounting this lightweight, absorbent paper.

>>>
I formed the stormy clouds by re-applying water to part of my Magical Marker landscape after it had dried.

STORM CLOUDS • Elizabeth Joan Black • Water-based marker on Oriental drawing paper • 4¹/₄" × 5¹/₂" (11cm × 14cm)

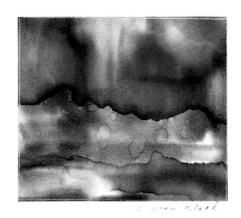

<<<
I folded absorbent paper into a small bundle, and colored the corners and edges with water-based markers. I lightly moistened the bundle on the edges with a brush so that the colors would spread in repeated patterns. I used two bundles for this card; one was wetter than the other and produced a different effect even though the same colors were used in both.

WINDOW DRESSING • Elizabeth Joan Black • Water-based marker on Oriental drawing paper • 5¹/₂" × 4¹/₄" (14cm × 11cm)

Gallery

>>>
Lois Sander's comets converge to draw our eyes to the central part of her composition.

COLOR DANCE • Lois Sander • Water-based markers with salt on coffee filters • 4$^1/_4$" × 5$^1/_2$" (11cm × 14cm)

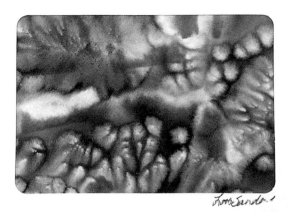

The dark lines in this piece lead the eye on an interesting path through the comets.

MULTITUDE • Lois Sander • Water-based markers and salt on coffee filters • 5$^1/_2$" × 4$^1/_4$" (14cm × 11cm)

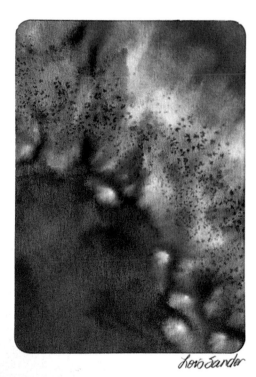

Quiet areas in this piece contrast and add to the drama of the flares of color.

FLARE OF HOPE • Lois Sander • Water-based markers and salt on coffee filters • 5$^1/_2$" × 4$^1/_4$" (14cm × 11cm)

label it FUN

Have you have ever looked at a set of colorful stickers in the store and wished you knew how to make your own? Thanks to the self-adhesive label you now can create and design personalized stickers! They not only make wonderful cards, but are also great decorations for almost anything. All you need to get started is an assortment of labels and a few simple supplies.

For sheer economy, I use a size which approximately measures $3^{1}/_{2}" \times 1"$ (9cm × 3cm) and can be purchased in boxes of five thousand. This brings the price down to about almost nothing! Other sizes and shapes may be a little more expensive. Working on labels means that you eliminate the frustration of gluing. Many types of media can be used on the labels including water-based markers, stamp pad inks, watercolors, metallic pens and gel pens. Please note that the removable style labels may have to be secured with a glue stick if you paint on them.

[MATERIALS LIST]

⊚ White, self-adhesive labels in various sizes and shapes

⊚ Water-based markers, broad and fine tipped, or watercolors in tubes or pans

⊚ Gold or silver metallic pens (the pressure pens like Pen-Touch or Pilot give the brightest lines but the ballpoint type or gels will also work)

⊚ ⅝-inch (1.6cm) and ¾-inch (1.9cm) border guides

⊚ Scissors

⊚ Wax paper to use for a resist

⊚ Ballpoint pen for drawing on wax paper

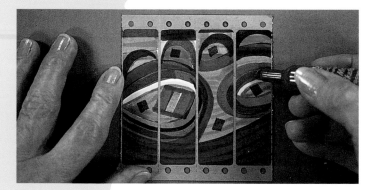

1 | Color on Labels

While the labels are still on their backings, decorate a group of four—or five of them for a crazy quilt pattern—with bands and blocks of marker color. You may leave some white areas showing, or not, as you like.

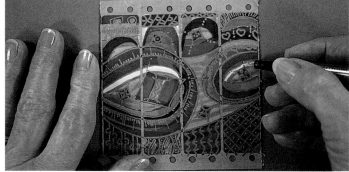

2 | Accent Your Pattern

Draw on top of the marker designs with your metallic pens. Have fun playing with repeated patterns, borders, swirls, cross-hatching and graceful scribbles—maybe even some words.

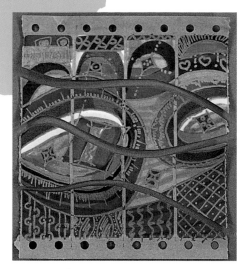

Decide on a Design

3 | You might cut three labels into thirds or fourths and arrange them as a grid design like a window.

Try a ⅝-inch Border Guide

4 | If you have a ⅝-inch (1.6cm) border guide, your three panels will fit the width of the window exactly. You can use it as a guide, or trace around the inside of the guide with a pen right on your paper. With the ⅝-inch (1.6cm) guide, put in your two top corners first and center your middle piece inside them, then continue to work your way down the card.

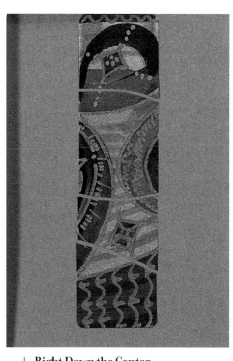

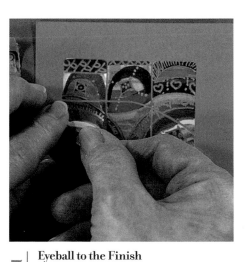

Try a ¾-inch Border Guide

5 | If you have a ¾-inch (1.9cm) border guide, then mark the middle of the top of the window on your guide. Lay your guide over your card and tape it down at two corners. Keep all your label pieces in order. Start with the top middle piece and center it against the top of the frame. This piece will be your cornerstone guide. Leave a tiny space and line up the next center piece going down and press it down. Space your pieces just far enough for the separation to be noticed.

Right Down the Center

6 | Continue to the bottom of the label. There will be a wider space at the bottom.

Eyeball to the Finish

7 | Take your card out of the frame. Starting at the top, arrange and press down the side panels. Try to make your spaces, both vertical and horizontal, the same width. Turn your card around to find the easiest and most comfortable way for you to work. You may find the one side of the border of your card is slightly wider; if so, just trim it to match the other side.

8 | Border Line

With your metallic pen and ruler, finish your piece with a border close to the label edges. If you are using a plastic ruler with a raised center part and a pressure-point type pen, turn your ruler over so that the pen point is held away from the paper. This will help prevent blobbing of ink. Don't worry if you are slightly uneven in your label placement. The exact edges of the labels will still give a crisp effect. Experiment with other ways to arrange your pieces. The labels also work well as envelope decorations, so try using your fourth panel on your envelope.

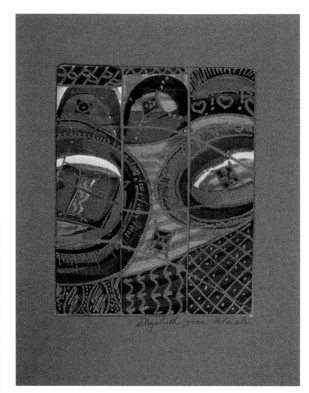

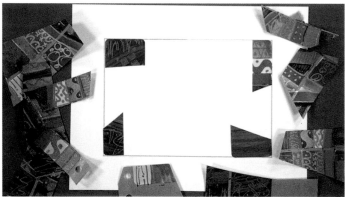

9 | Make a Crazy Quilt

With your gel or metallic pen, trace a $3/4$-inch (1.9cm) border inside your guide on your card. Cut your five decorated strips into random pieces and begin putting down pieces in the corners; it's okay to overlap your pieces. Fill in the borders and work toward the middle. Try to get patterns to line up and relate to each other. The design will change dramatically with each piece you put down. Remember to try to create a focal point.

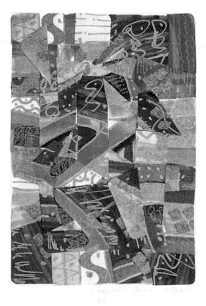

10 | Use Tweezers

You might find it easier to put in some of the small pieces with tweezers. If you run out of pieces use the same colors and make another strip or fill in the spaces with metallic ink designs.

11 | Try Turning It

You may find that it has more appeal turned a different way.

Try Something New

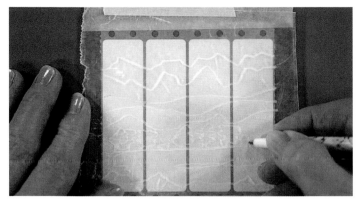

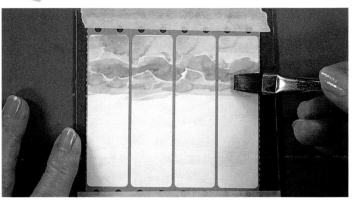

1 | **Try to Resist**
Secure a group of four labels, with their backings still attached, to a piece of stiff bristol board or mat board with masking tape. Place a piece of waxed paper over the labels and draw firmly on them with a ballpoint pen. The wax lines will adhere to the labels and form a resist. Try a simple landscape such as craggy mountain peaks, curved foothill lines, scribbly trees, quiet water and rocky foreground. Don't worry about your drawing ability, because the paint will change what you have drawn anyhow. Remove the waxed paper.

2 | **Make Your Lines**
Load your brush with paint and wipe it several times on your palette. Make very light strokes of paint over the wax lines to make them pop out. Be careful, if your brush is too full, or you scrub the paper, your wax lines will disappear.

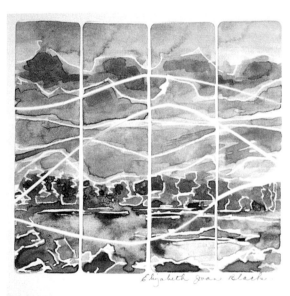

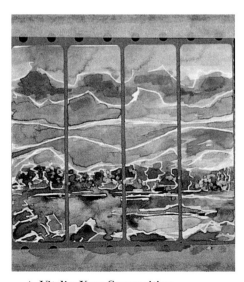

3 | **Vitalize Your Composition**
Continue down your landscape dropping in some darker colors to give vitality to your composition.

4 | **Mount Your Panels**
Four labels will mount nicely leaving a narrow border on your card. You may not wish to cut the labels at all. Experiment!

>>>

I drew the flowers in a very free, loose style on the labels and crowded them together. I placed the wax tracing beside the labels to use as a guide when I applied the color. I decided to cut the labels, but you could leave them intact.

SUMMER SONG • Elizabeth Joan Black • Watercolor with wax resist on mailing labels • $4^1/_4$" × $5^1/_2$" (11cm × 14cm)

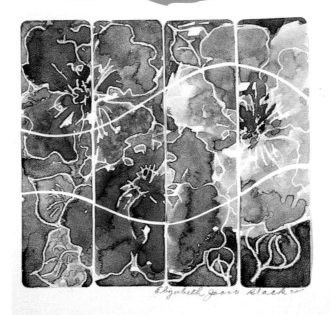

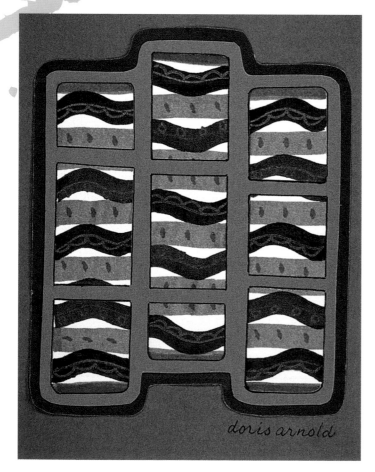

<<<

By simply shifting the label panels, Doris Arnold achieved an interesting outside shape along with a rhythmic inner design.

THE PURPLE WAVE • Doris Arnold • Water-based markers on mailing labels • $5^1/_2$" × $4^1/_4$" (14cm × 11cm)

Gallery

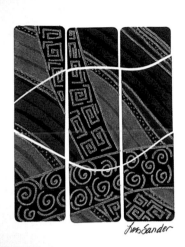

>>>

Lois Sander combined both cut and drawn lines to give the feeling of the fluctuating market graphs.

STOCK MARKET • Lois Sander • Water-based markers and metallic markers on mailing labels • $5^{1}/_{2}" \times 4^{1}/_{4}"$ (14cm × 11cm)

Lois Sander planned her design so that no lines led directly out of the corners, which would draw your eye away from the focal point.

INTERSECTION • Lois Sander • Water-based markers and metallic markers on mailing labels • $5^{1}/_{2}" \times 4^{1}/_{4}"$ (14cm × 11cm)

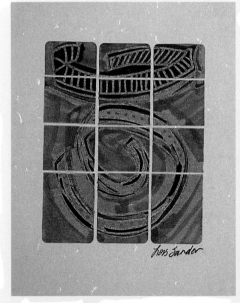

Lois Sander placed the pink horizon well above the middle of the card to give the composition graceful proportions.

RINGO • Lois Sander • Water-based markers and metallic markers on mailing labels • $5^{1}/_{2}" \times 4^{1}/_{4}"$ (14cm × 11cm)

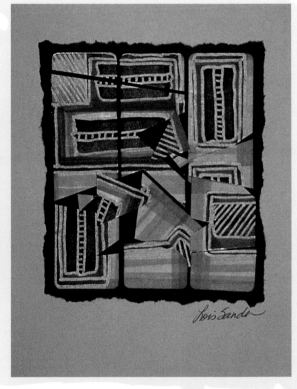

<<<

The torn black undermatting on *Chaos* plays up the mood of the composition.

CHAOS • Lois Sander • Water-based markers and metallic markers on mailing labels • $5^{1}/_{2}" \times 4^{1}/_{4}"$ (14cm × 11cm)

3 wrap up COLOR

There is an amazing technique hiding in your kitchen. It's plastic wrap. You can create wonderful and unusual textures by applying wrinkled plastic wrap over wet paint. You can use a variety of water-based colors with a touch of gold or silver ink to achieve stunning effects. Start with the materials you have on hand. You'll be amazed at what you can create!

[MATERIALS LIST]

⊚ Liquid watercolors, colored inks, food coloring, liquid acrylics, pearlescent acrylics, tube or pan watercolors mixed to liquid, or any type of water-based art colors. The transparent colors will give the most effective blends. It's handy to have dropper bottles, but a brush will also do.

⊚ 90-lb. (190gsm) hot-pressed watercolor paper. You can cut twenty-five pieces—measuring 4⅜" × 6" (11cm × 15cm)—from a sheet of 22¼" × 30" (57cm × 76cm) paper. Cold-pressed watercolor or other papers will also work, so experiment.

⊚ Plastic wrap, dry cleaner bags or supermarket vegetable bags cut into 8-inch or 9-inch (20cm or 23cm) squares

⊚ Gold or silver ink sediment applied with an unwound paper clip

⊚ Pan of water for wetting the watercolor paper

⊚ Pieces of heavy cardboard or mat board about 6" × 8" (15cm × 20cm) to hold your paintings. Cover the boards with newspaper to prevent paint from sticking to them.

⊚ Viewfinders of various sizes (use your border guides) or two L-shaped pieces of border to use as viewfinders

⊚ Discarded magazines with glossy paper to use as a working surface as you apply glue to the back of your compositions

⊚ YES glue or a tacky craft glue, double-sided tape or a glue tape dispenser

⊚ Stiff glue brush if applicable

Wet and Wild

1 | Check that your colors are all ready to use and your piece of plastic wrap is close at hand. Immerse your piece of watercolor paper in water, shake it off and lay it on the paper-covered cardboard. Now you can work quickly and spontaneously as you drop liquid watercolors on the wet paper. Try standing up to drop on your colors; it will loosen up your style. Enjoy the effects as they spread and blend.

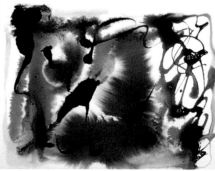

Dramatic Colors

2 | Apply some dark colors along with light colors to get the most dramatic effects. You can also leave bits of white showing if you like. Use the whole sheet, as you will be cutting up the paper to mount it, and even tiny pieces will have great vitality and be useful.

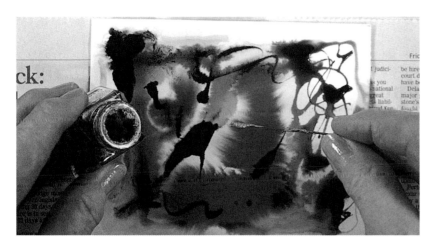

Precious Metals

3 | With the paper clip tip, scoop up several small gobs of gold or silver sediment from the bottom of your ink bottle. Drop and spread them on the paint. Remember, just a touch of precious metals! Too much gold makes it look like brass, too much silver makes it look like aluminum. Work quickly!

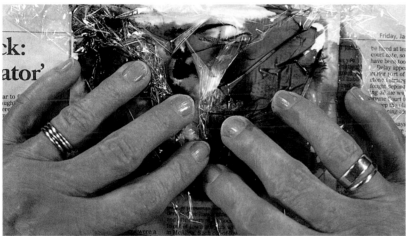

Wrinkle and Relax

4 | Pick up your piece of plastic wrap and let it relax and wrinkle. Lay it over your wet painting all wrinkled up so that your design can take shape. Open your fingers like claws and press them toward each other on the plastic to spread the paint and ink. Where dark paint is caught in the wrinkles you will get a crystalline effect. Stop when you are happy with your design. If you work the plastic too much you will end up with mud! Set your painting aside to dry overnight. The colors will change as they dry.

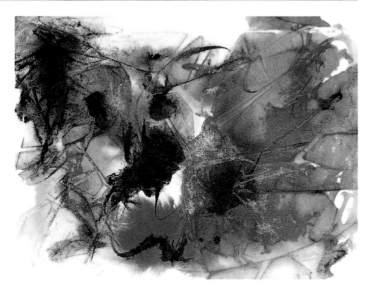

Surprise Suggestions

5 | Look at your piece and see what it suggests to you. Look at the back of your paper too, it may also hold some surprises. The dark blotch in the middle had a menacing look about it. I thought I might be able to use it in a scary or fall theme.

Take Control *of* Your Painting

So far the watercolor has been mostly in control. Now it is your turn to take charge and present your painting in an effective way. Call upon all your design knowledge and your intuition to do this.

Try Many Approaches and Angles

Look at your painting to see if it has a focal point or several spots that could be focal points. Choose several different sizes of viewfinders (or two L-shaped borders) and run them over your dry painting to help you see possible compositions. Your focal point should be slightly off center, but near the middle of your composition. Remember the focal point may be:

⊚ the brightest spot

⊚ the spot where the lightest and darkest parts come together

⊚ the spot that draws your eye to it

How to Add a Focal Point

What if you don't seem to have a focal point? You might add one with a dash of gold ink, gold pen or bright opaque color with pencil, crayon or gouache. You could cut up your painting into a series of related shapes such as baubles or bottles and make the shapes the dominant design element in a planned composition. If your painting is mostly in coordinated pale colors you may be able to mount most of it as one piece. If it is very dark and rich looking, it will likely look more effective cut into jewel-like smaller pieces to mount. If it appears to have several separate color schemes, it will also likely work better cut into several pieces.

If your painting has many unrelated colors in it, slice it up into panels. The background becomes a unifying factor, and makes your painting sing! Look at the back of your painting too—sometimes it holds more possibilities than the front. Use your painting as an effective background for collage, and add to it until it stars as an "anything-goes" painting. If you cannot find a way to use it just now, put it in your recycle bin to be taken out and assessed later. Whatever you do, don't throw it away!

Define Your Designs

Try using your viewfinders or two L-shaped pieces of border to find interesting designs in the watercolor piece. Move the pieces around and turn your painting in different directions, including the diagonals, as you search for interesting compositions with a definite focal point. As you consider different views, avoid having lines that shoot right out of the corners and white or light spots right at the edges that pull your eye away from the main subject.

If at First You Don't Succeed...

Try finding at least half a dozen compositions in your large piece. If you are like me, not satisfied with what you find, then take a break and peel the potatoes for supper! When you come back with a fresh eye you will likely find what you are looking for.

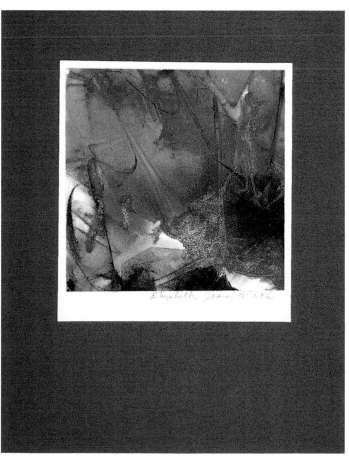

Surprise! A Fisherman!

I came back, casually dropped a different size of frame on the card and immediately saw the composition I wanted to use. There was a fisherman in a deep forest! The little waterfall was precariously close to the edge but it led into the picture quite acceptably. There was hardly any of the menacing dark blotch that occupied my thinking before. I mounted it on a white mat to show it off, and it turned out to be very different from the composition I had expected to find. Be open to changing your mind!

Elegant Edges

Once you have selected the square or rectangular piece that you wish to mount, consider how to make the edges. An artistic and simple way to make an edge is to tear your paper. However, a simple straight edge also works.

Using a Paper Trimmer or Craft Knife

If your trimming line lies close to the edge, a clean cut with a paper trimmer, scissors or a craft knife will likely work the best. You could also try to "square up" your edges. This is the place to take care. In turn, push each edge of your composition right up close to the top of the paper trimmer to see if the edges are squared up. Or use your triangle and a craft knife to square up your piece.

Mounting Your Art

If you have a choice of colored card stock for mounting your watercolor, try your pieces on various colors to see what looks most appealing to you. Set your watercolor on a piece of white or gray paper, letting a very narrow undermat show on top of the colored card, and see if it brings your painting to life. If you are limited to white card stock use a very narrow (about $1/16$ of an inch [2mm]) colored undermat to pick up a color from your art and help your presentation. A gold or silver pen line right up against the edge of your painting will also help bring it to life.

Guard Those Borders

Take special care with your borders, that is the part of the card showing around your painting. Review the hints about borders in the Quick Start Guide (pages 11-12). Be sure that your borders enhance your painting and set it off gracefully. Lay your card on the floor and look at it from a distance before you glue it. Ask yourself, "Are the edges lined up?" "Do I have at least two borders the same width?" "Is the wider border at the bottom of the card?" Take your time deciding just where your art looks best on the card.

Gluing Like a Pro

Be sure to use a new magazine page each time you apply glue. Hold down your watercolor piece securely with two fingers to keep it from wiggling, and brush the glue right out past the edges. YES glue, a tacky craft glue or double-stick tape will keep the watercolor paper secured to your card. Glue stick will likely pop off a glazed card stock background when dry. White glue will hold, but tends to buckle your paper. Remember to wrap your card in plastic or waxed paper before you press it under a stack of books.

Mark and Measure

Mark your corners on the front of your card with pins pushed through into a backing piece of corrugated cardboard. Carefully mark the pinholes on the back as you pull out the pins. Connect the pinholes with the tearing lines and extend the tearing lines for your composition right to edge of your paper. Put your watercolor on the table upside down, and line up your tearing lines with the sharp edge of a straight table top. Place a ruler over the paper, also lined up with the edge you want. Bend the paper up and down to prepare for the tear.

Tip You may want to tear from the front or the back of your art. Tearing from the front will give a slight edge. Tearing from the back will give color right to edge of your chosen composition.

Go Ahead, Use Your Fingers

Hold the ruler down very firmly and gradually tear the paper upward with your fingers. Of course you need enough paper to hang onto to be able to tear easily. If you cannot hold onto the paper, use a paper trimmer.

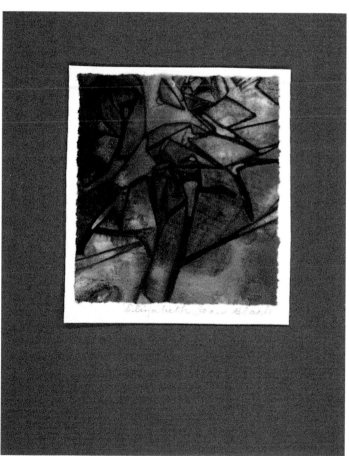

Show Off Your Torn Edge

Mount your composition on a contrasting color of undermat to show off the torn edge. Try several very narrow widths of the contrasting color. Remember, you need only enough undermat showing to bring your painting to life, not to overpower it.

Elizabeth Joan Black.

<<<

I first covered my paper with waxed paper, and made a loose drawing of small flowers with a ballpoint pen. I then applied watercolor and plastic wrap over the wax outlines. As the paint dried some of the wax showed through, adding just a bit of realism to the otherwise loose, flowing colors.

HIBISCUS • Elizabeth Joan Black • Wax, liquid watercolor on Arches 90-lb. (190gsm) hot-pressed watercolor paper • $4^{1}/_{4}$" × $5^{1}/_{2}$" (11cm × 14cm)

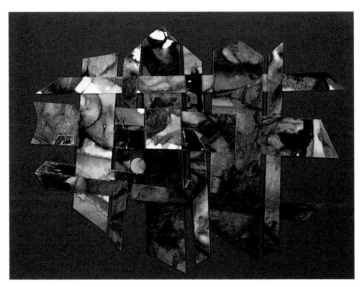

My original had an all-over design, so it lent itself to being transformed into a woven composition with some accents of gold.

GOLDEN SOLITUDE • Elizabeth Joan Black • Liquid watercolor, gold ink, gold paper on Arches 90-lb. (190gsm) hot-pressed watercolor paper • $4^{1}/_{4}$" × $5^{1}/_{2}$" (11cm × 14cm)

doris arnold

Doris Arnold used salt and plastic wrap to her advantage, giving a totally crystalline look. The light pink crystals surrounded by blue draw the eye to the nicely placed focal point.

GEODE • Doris Arnold • Watercolor, salt and plastic wrap on watercolor paper • $5^{1}/_{2}$" × $4^{1}/_{4}$" (14cm × 11cm)

Gallery

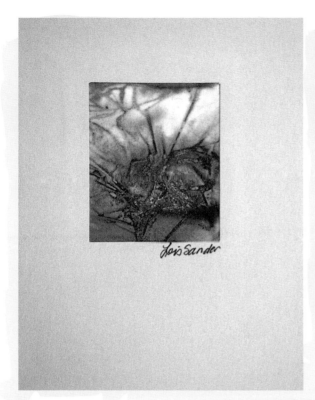

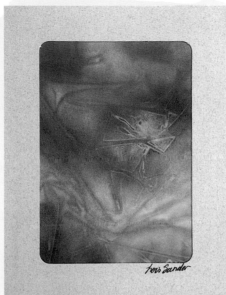

<<<

The soft lines and large areas of blended color work well in this large composition.

WINTER ROSE • Lois Sander • Watercolor and plastic wrap on 90-lb. (190gsm) hot-pressed watercolor paper • $5^1/_2$" × $4^1/_4$" (14cm × 11cm)

The delicate gold bough and the fine patterns in this painting call for a small piece to be mounted so that you can enjoy the richness of detail it contains.

GOLDEN BOUGH • Lois Sander • Watercolor and plastic wrap on 90-lb. (190gsm) hot-pressed watercolor paper • $5^1/_2$" × $4^1/_4$" (14cm × 11cm)

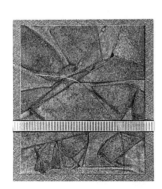

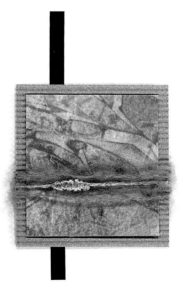

The division of the plastic wrap panel into a one-third, two-thirds proportion makes a graceful background for the delicate bead and thread accent.

CRYSTAL THOUGHTS • Donna Livingston • Collage with thread, bead and watercolor with plastic wrap • $6^5/_8$" × 5" (17cm × 13cm)

Donna Livingston loves to work with fine details and precise edges. The free flowing plastic wrap panel provides a pleasing contrast to the geometric mounting.

PARADISE BLEND • Donna Livingston • Collage with thread and watercolor with plastic wrap design • $6^5/_8$" × 5" (17cm × 13cm)

MINISCAPES
capture the moment

For me, working small in watercolor is faster, easier, more econo-mical and less daunting than working in a larger scale. While many of us would hesitate to tackle a whole sheet or even half a sheet of watercolor paper to produce one painting, the pressure is off when we work on paper card-size or less. When your little sheet of paper costs next to nothing you can relax and have fun seeing how the watercolor will do its thing with very little help from you. In fact this is the way you will achieve the most striking work. Try to capture the moment in your miniscapes. Look at these tiny paintings as first impressions, a fleeting glance, the flourish on a signature, a sponta-neous skip. Let the spirit of the moment shine in them. Miniscapes remind me of haiku verses, capturing the essence of now.

Cutting your Paper

We all have personal preferences when it comes to the size and shape of paper we like to work on. To find out what works best for you, be daring and try many different ideas. The largest size I use on cards is about 3" × 5" (8cm × 13cm) paper. Painting on long narrow shapes such as 1" × 4" (3cm × 10cm) lets you concentrate on a hori-zon line and will often help you to loosen up. I found that painting on a 2½-inch (6cm) square is a refreshing change from constant rectangles. I encourage you to play and experiment with postage stamp-size pieces from trimmings, instead of throwing them away. Taping down the paper limits you to straight edges.

Setting Up to Paint

While you can make a grid of miniscapes on a large sheet of paper, I prefer to handle each miniscape separately. I like the freedom of holding each painting in my hand and being able to turn and tilt it to let colors blend. I tape each piece of paper to a separate piece of card-board with masking tape. I use about a ¼-inch (.6cm) border and press the tape down very firmly with my fingernail to make a water-proof seal all around the paper. This is an important step, for when you pull the tape you want to see a clean, white mat.

Have your paints moistened and ready to use. Prepare at least four miniscape papers, taped and ready to paint. Put on your favorite music to relax you and begin. Remember to:

- limit your colors
- work quickly
- dash in with your paint
- let it work for you
- leave it alone! leave it alone! leave it alone! The hardest part is knowing when to stop.

[MATERIALS LIST]

- 90-lb. (190gsm) hot-pressed or cold-pressed watercolor paper cut into small pieces.
- Blue, red and yellow watercolor paint. These paintings are so small, you will be most successful with a very limited palette of the three primary colors, but experiment to find combinations you like. If you are using tube watercolors you might try Winsor Blue, Burnt Sienna and Thio-Indigo Violet.
- Table salt or coarse pickling salt
- Pieces of corrugated cardboard backing larger than your watercolor pieces to allow for taping.
- Masking tape or artist's tape for holding your paper in place on the backing and to create a white mat around your painting.
- YES glue or tacky craft glue or double-sided tape for mounting
- Atomizer
- Old credit card

Tip Buy the best paper you can afford, that is handmade, all-rag content watercolor paper. Some student-grade papers, especially pads, are machine made. The paper looks like a tractor has run over it to give it texture. It will not give you the pleasing effect of the handmade paper.

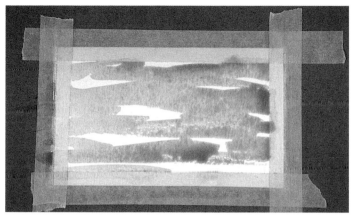

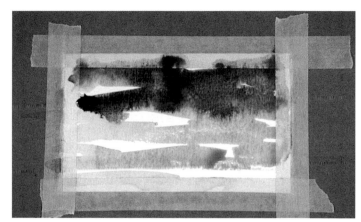

Let Loose with Your Wash

1 | With your ½-inch (13mm) brush and clear water (or a very pale wash of one of your primary colors) wet your paper in loose horizontal strokes, leaving a few narrow streaks and small patches dry. Tip your paper and let the water move around, but preserve the dry white areas. Mop up any large drips running off the edge.

Drop in Your Sky

2 | You may want to create a strongly colored miniscape or a very delicate one—the choice is up to you. Remember that your watercolor will be paler when it is dry, so for now think vibrant. Pick up some very intense sky color (maybe blue) on your brush and touch it to the wet sky area. Enjoy what happens as the paint and water start creating a sky for you.

Highlight Your Horizon

3 | With your red, drop in a narrow horizon just above or below the middle of your painting. Tip your paper to help the horizon and sky blend in a few spots.

Color Your Foreground

4 | Keep preserving the dry white areas as you drop in your yellowish earth colors, such as Burnt Sienna, near the bottom of your painting. White areas give contrast in your composition and can always be toned down.

Let the Sun Shine

5 | A tiny bit of yellow dropped in the sky will give a sunny effect. Bits of intense blue and a touch of red dropped into the yellow foreground will yield greens and other vegetation colors. By using just the three primaries, your color scheme will be coordinated, giving unity to your piece of art.

While the painting is still wet, make vertical touches with your loaded brush to suggest irregular groups of trees. Vary the number and sizes of your groupings. Make upward strokes with the edge of a credit card through both your painted and dry areas to suggest trees.

Paint over any distracting white bits at the edges that lead your eye off the painting. Squint at your painting to see if you need to define your focal point more. This may be the time to drop in some dark accent colors or to add just a few grains of salt—while the paint is still slightly wet and shiny—to form crystalline designs in limited areas. Often I set each painting propped up at an angle to dry so that the paint gathering at the edges of the dry areas can gain intensity.

Unveil Your Creation

6 | You are now ready to unveil your creation! Carefully pull the tape away from the painting. Your exposed white mat border will let your painting spring to life. Re-assess your painting again. Does it need just a touch of bright orange or yellow to bring out the focal point?

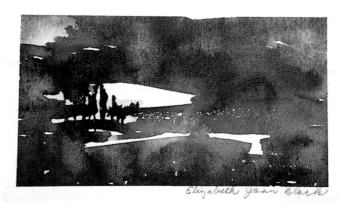

Full Steam Ahead

7 | If your painting has buckled or warped, you may want to steam iron the back to make it lie flat again for gluing. Now look for a card color—or a very narrow colored undermat if you are using white card stock—to complement your piece. Remember to consider the placement of your card to give the most pleasing borders. Title your paintings and sign them in tiny writing with a pencil so as not to overpower your art. Enjoy!

Make More *of* Your Miniscape

Nobody says that a miniscape must look like a landscape. You might fill your bits of paper with floral shapes or fanciful blends of color that are simply pleasing to behold. When you approach floral shapes think of looking though the lens of your camera at a bed of flowers. Their edges will go outside of the frame forming interesting shapes in your composition. Let your flower edges do the same thing to keep your blooms from floating in space in the middle of your painting. Centers may get lost, so try starting with them.

1 | Start at the Center
Dot with a pencil an uneven number of centers (three or five may be about right) placing them at different levels so that you can paint small, medium and large flowers in your miniscape. With the corner of your brush, tip in intense dots for centers.

2 | Load on the Flowers
Make sure your paper is thoroughly dry, then choose a color for your first flower. Wet your brush and load only one corner with paint. The gradual blending of paint will create delicate throats in your flowers. With the loaded corner to the outside, leaving some white space around your centers, loosely suggest petals around your first center. Remember to go over the edges of the paper and out onto the tape. For the second flower, choose a slightly different color and make it either larger or smaller. As you paint, turn your painting around to make it easier for you to handle. Make the third flower a different size, and choose another color or a blend of colors for the one corner of your brush. Remember to push your flowers over the edge.

3 | Intensify the Background
With your chisel brush, lightly wet the background areas with clear water. Drop in intense colors for the background. Blend in some of the flower colors to give unity. With the corner of your chisel brush (or a tiny brush), fill in any delicate-looking areas that define petals. Spray your painting lightly with an atomizer to give it a freer look. Enjoy what happens when the paint takes over. Set the painting to dry and go on to the next one.

A Flourish of Flowers

4 | Mount your painting on a suitable background color. Add a flourish of stamens with strokes and dots using dark paint and your tiny brush or a metallic pen.

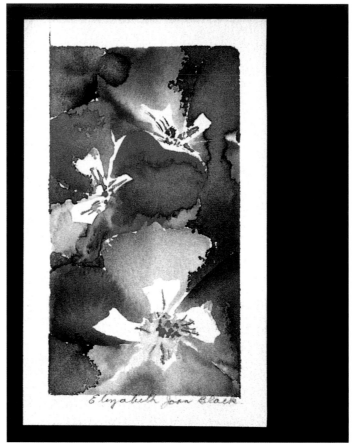

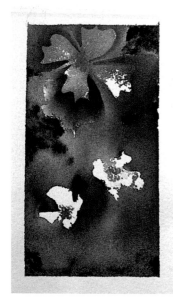 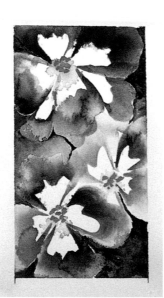 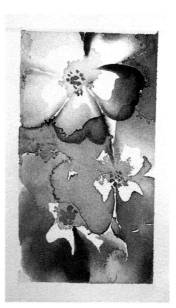 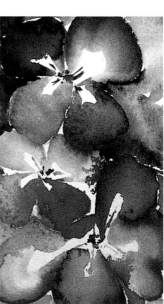

You will find that the more miniscapes you paint and assess, the more satisfying your paintings will become. The key is to paint lots and assess thoughtfully. After being away from this technique for a time I found that I had forgotten much of what I once knew. It took me several tries, critiquing each painting to see how I could improve, in order to get into the spirit of the florals again.

In my first try the centers were either lost or too harsh and I didn't define the petals. I realized that in my second try I did not vary the colors of the flowers, and the throats were sharp and "unflower-like." The third attempt was getting more delicate-looking. On the fourth try I did not even bother taping down the paper. I loosened up and quickly dashed on the paint achieving a much more flower-like effect. So do not be discouraged—instead be open to surprises and possibilities!

Ideas to Try

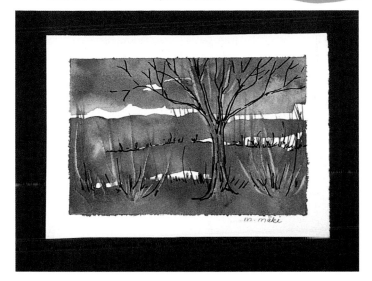

‹‹‹

Margaret Maki accented her painting with graceful pen strokes to give definition to the trees and grass. Try this technique yourself. First, practice your pen lines on scrap paper to loosen up your style before you work on your painting.

WINTER TREE • Margaret Maki • Watercolor and black ink on watercolor paper • 4^1/$_4$" × 5^1/$_2$" (11cm × 14cm)

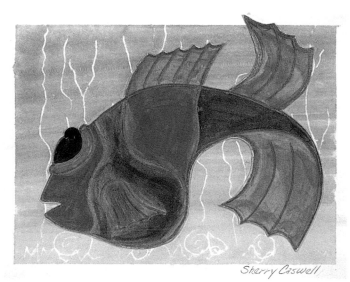

Sherri Caswell designed her own lively fish after looking at photographs of many different fish. She painted the fish in shiny acrylic paint, cut it out and mounted it on a background of waxed paper resist and watercolor.

WHAT'S UP? • Sherry Caswell • Pearlescent acrylic paint, wax and watercolor on card stock • 4^1/$_4$" × 5^1/$_2$" (11cm × 14cm)

I find that a clear light color like yellow can often end up diluted and muddied in a painting. In *Slice of Blue*, I first applied areas of yellow wax crayon that would resist the paint and remain clear. I made some scratched flourishes with a compass point over the crayon and paper, then applied the intense red and blue paint. I pressed a bit of wrinkled plastic wrap into the wet paint at the top edge to give a crystalline effect as it dried.

SLICE OF BLUE • Elizabeth Joan Black • Wax crayon, watercolor and plastic wrap on 90-lb. (190gsm) hot-pressed paper • 4^1/$_4$" × 5^1/$_2$" (11cm × 14cm)

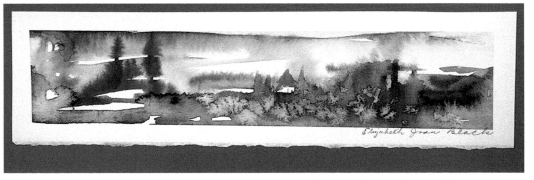

Folding the card paper lengthwise yields a card that will fit in a no. 10 envelope. It also creates the background for a panorama style of painting. I used a bit of salt to give texture. It is challenging, yet rewarding to paint on a long panel of paper. Try it.

NORTHERN PASSAGE • Elizabeth Joan Black • Watercolor on 90-lb. (190gsm) hot-pressed paper • 2^3/$_4$" × 8^1/$_2$" (7cm × 22cm)

Gallery

>>>

Joanne Elvy's first evening of watercolor rewarded her with a very delicate and evocative miniscape. She created the graceful white spaces by relaxing her first few brush strokes.

SOLSTICE • Joanne Elvy • Watercolor and salt on 90-lb. (190gsm) hot-pressed paper • $4\frac{1}{4}" \times 5\frac{1}{2}"$ (11cm × 14cm)

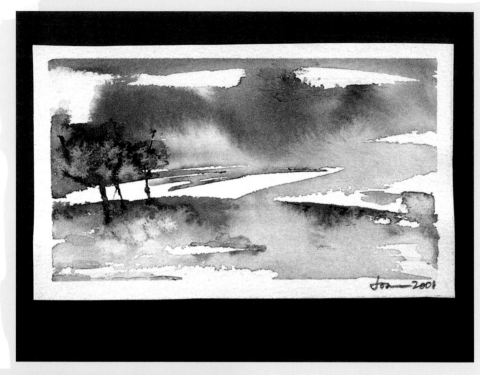

<<<

The startling shapes and colors in the sky of Rose Marie Fero's painting give a feeling of stormy excitement behind the stately bulrushes.

NORTHERN BULRUSHES • Rose Marie Fero • Watercolor on 90-lb. (190gsm) hot-pressed paper • $4\frac{1}{4}" \times 5\frac{1}{2}"$ (11cm × 14cm)

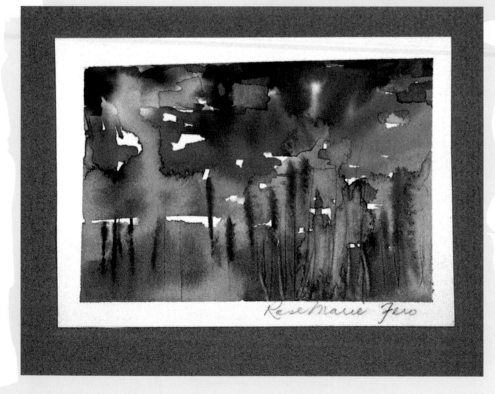

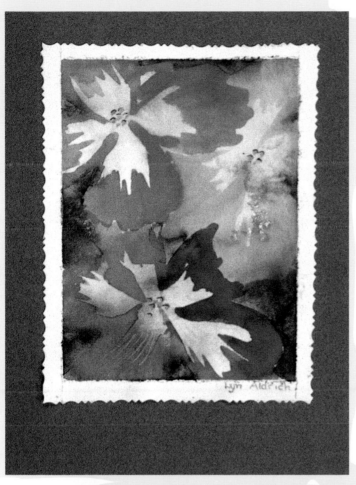

<<<

Lyn Aldrich's flowers in related colors push out of the edges of her painting creating varied background shapes.

SPRING BREAK • Lyn Aldrich • Watercolor on 90-lb. (190gsm) hot-pressed paper • 5^1/$_2$" × 4^1/$_4$" (14cm × 11cm)

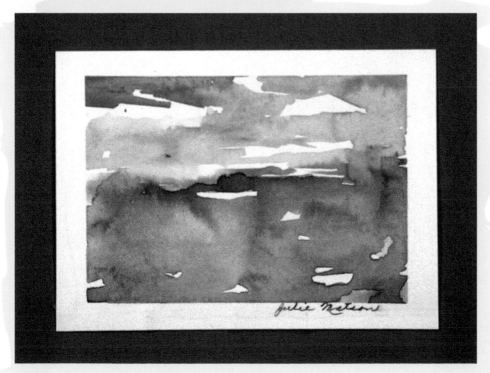

<<<

Julie Matson's horizon line leads the eye back to the blue hills in the background, which rise well above the middle of the card giving a pleasing division of land and sky.

PRAIRIE HORIZON • Julie Matson • Watercolor on 90-lb. (190gsm) hot-pressed paper • 4^1/$_4$" × 5^1/$_2$" (11cm × 14cm)

stunning STENCILS

A multi-colored stamp pad, a handful of cosmetic sponges or daubers, a treasure hunt bag of stencil materials, plus your imagination and a bit of time can bring you a delightful array of colorful cards. The stencil materials you are looking for include any kind of flat materials that have openings in them such as netting, lace and paper or plastic doilies. Soon you will see all kinds of potential stencils around you as you go about your daily routines—look for them in packaging materials, in things around your home, out in nature, as you are shopping. You might have to buy those onions just for the netting!

Use a Border Mask to Enhance Your Work

A border enhances most artwork, so before making these cards you need to make a mask that will keep a plain border around your design. You can use this masking frame many times over even if the front of it becomes stained with ink. A ³/₄-inch (1.9cm) border mask all around your design will set it off nicely. However, try making masks of different widths to see what suits you best. As a bonus, with a mask of even width, your card can be viewed either horizontally or vertically. Sometimes you may plan a design to go one way and when you are finished it looks better the other way. An even border gives you the option to change your mind. You can also cut out your composition and remount it.

How to Make a Folded Border Mask

Fold a piece of card stock in half to make a card. On the front of the card measure—or trace from your border guide—a border all the way around that is ³/₄-inch (1.9cm) wide or whatever you choose. Cut out the inner rectangle you've drawn on the card to form a window where your design will take shape. Extend your cutting lines to the edge of your paper to help you cut exactly with your craft knife. If you use scissors, spear your scissors into the center of the window and cut to the corners of the inner rectangle. This will help you easily cut out the window. Take care to be as accurate as you can and make neat squared or very slightly rounded corners as you will use this mask many times over.

[MATERIALS LIST]

- Bright white card stock to use as your basic paper
- Several wedge-shaped foam cosmetic sponges, or better, daubers which you can make yourself, for applying color. Note: Cosmetic sponges are better than daubers if you are using stencils made from yogurt container lids.
- Multi-colored stamp pads
- Selection of found stencils—any kind of thin plastic, cloth or paper that has openings in it. Some suitable materials are netting, onion bags, lace, curtain materials, dry wall tape, plastic doilies, the sides of lacy plastic strawberry baskets or Sinmay ribbon (a kind of loosely woven fiber ribbon made in the Philippines and sometimes found in craft and floral shops). Woven cheesecloth also makes a good stencil, dip it into milk and let it dry to stiffen up the threads, so that it does not stick to your sponge.
- Masking tape
- Disposable plastic gloves, moist wipes or a wet washcloth to keep your fingers clean if you are using stencils.
- Sharp pencil for signing your art
- Scissors or a craft knife for cutting masking borders
- A hole punch that makes varying sizes of round openings
- 3-mil acetate, plastic sheet protectors or tinted plastic report covers for making into masks and stencils
- Fine-point black ink pen, such as a Micron .01, for adding flourishes

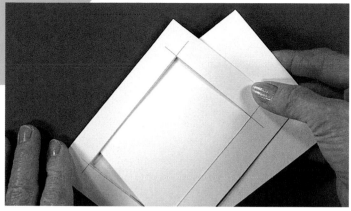

Setting Up

1 Fold a new piece of card stock and slide it snugly inside the masking frame with the folds touching. Decide if you are going to work vertically or horizontally, and check to be sure your finished card will show your composition on the front. Tape down two opposite corners of the masking frame to hold it securely on your work surface. Now you are ready to apply your color.

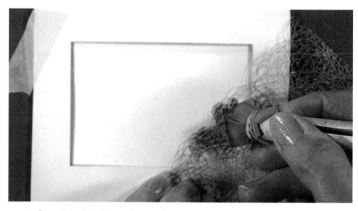

Starting Out Your Stenciling

2 Choose a piece of stencil material, such as a piece of netting, and lay it over your card. Eventually, you will work out a system that best suits you, but you might try starting out with lighter colors and working in from the edges first to build up your design. Use your dauber or curl your sponge around your finger and rub it on a spot in your stamp pad to pick up the color. Holding your stencil firmly, press your loaded dauber firmly on the stencil several times in a rolling motion. Make sure that the color comes though the openings.

MAKING TOOLS FOR THE JOB

Some of the fun of creating cards is devising tools for the job. Daubers will keep your fingers clean and give a more controlled ink application than the cosmetic sponges. You might like to make one and decide for yourself which you prefer to use to apply your ink. Ideally it is good to have a separate dauber for each ink color you are using, but daubers can be easily wiped off with a damp cloth or wet sponge between colors. Therefore, one may be adequate for a start. For each dauber, you'll need:

- Handle that is ½-inch (1.3cm) or more in diameter such as 2-inch (5cm) lengths of ½-inch (1.3cm) wooden dowel, old marker pen bodies, corks or ¼-inch (1.3cm) wooden doll pins (they look like old-fashioned wooden clothes pins, and are available at craft supply stores). The doll pins have the advantage of having a neck that helps to secure the rubber band, and a slit in the handle that enables you to slip them over a tin can edge for storage to keep them handy. Cally the cat donated her small food tin to me and it works well as a holder with a stone in it to keep it from tipping.
- Cotton ball for padding the end of the handle to give it some "cushion," and to ensure good coverage of ink
- Piece of 2mm craft foam size 2" × 2" (5cm × 5cm) for the pad
- Rubber band to secure the foam

Daubers can be easily cleaned with a wet cloth. Sponges, being more porous than foam, tend to absorb more ink and will stain but can be washed out and used over again until they dry out and start to crumble. Wash them by hand in an old onion bag, rinse and hang up to dry.

If you are using dye-based stamp pads, and you intend to blend colors on the pads, you may want to have larger daubers made on handles such as corks or plastic film canisters. Just use a larger piece of foam and cut to fit as for ½-inch (1.3cm) handles.

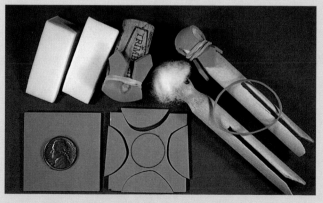

How to Make Your Dauber

For a ½-inch (1.3cm) handled dauber cut a 2-inch (5cm) square of 2mm craft foam for the pad. For the dauber foam pad, draw around the end of your handle and enlarge the circle about ⅛-inch (.3cm) all around. Or put a small coin, such as a nickel, in the middle of the foam and draw around it. With your scissors cut a "bite" out of four sides of the square reaching almost to the circle line to shape the foam to fit your handle. Your foam should look like a skinny cross. To give your dauber a cushion, cover and round one end of the dowel with some cotton padding. Center the foam square over the cotton and secure the foam arms to the handle with a rubber band.

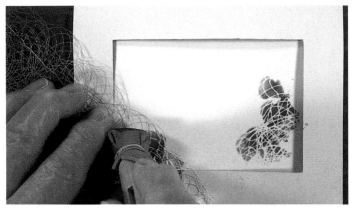

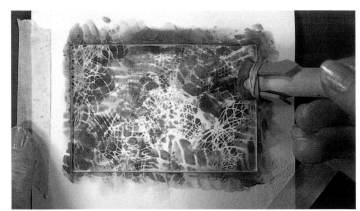

3 | **Design Details**
Reload your dauber and apply the same or a similar color in two or more corners to hold your composition together. Remember to repeat colors, and vary the size and shape of your colored areas and patterns. Switch to a different stencil and use a clean dauber to pick up a different color. Keep experimenting with more stencils and colors. Enjoy what happens when you overlap designs and blend colors. Try to aim for a focal point.

4 | **Make Your Edges Blush**
Define the border of your card by "blushing" in the edges with your dauber using soft colors that are in your composition. Brush inward from the mask with just enough color to give a continuous edge to your composition.

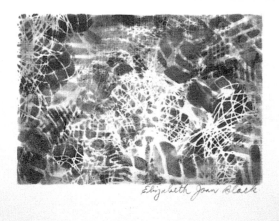

Elizabeth Joan Black

DESIGN HINTS

1. Choose related colors to be the dominant ones used in most of your card—e.g. warm colors such as red, yellow and orange.

2. Choose smaller amounts of contrasting colors for accents—e.g. cool colors such as blue, green and turquoise.

3. Start at the outside edges with your dominant colors. Make three or four corners the same color to hold your composition together.

4. Build your design toward your focal point just off-center where you will try to have your greatest contrast. This is where the lightest and darkest spots come together—e.g. white paper and deep reddish-orange. It might be helpful to make a pencil dot where your focal point could be so that you will have something to aim for!

5 | **Slide Your Card Out and Smile**
Be sure that your hands are clean to unveil your card. Carefully undo one corner of the masking frame and slide your card out. The border will bring your composition to life. With a very sharp pencil and in tiny writing, title and sign your card close to your art, aligning your writing with the edges of your work.

Tip Set up your card where you can look at it. Your first cards may turn out to be all-over designs, which can make delightful backgrounds for other art such as collage or calligraphy, or they may stand on their own. If you should make a blur or a mark on your border you can always cut your design out and remount it. Remember—almost any "mistake" can be recycled into a useable card!

Using Sinmay Ribbon or Cheesecloth as a Stencil

Just one piece of Sinmay ribbon or cheesecloth pulled into a distorted weave can provide a range of design possibilities. Remember to treat your cheesecloth to a milk bath before you use it.

Using Leaves as Stencils

Many kinds of thin, lacy leaves and foliage will yield interesting results when used as stencils. Sometimes it is necessary to tape parts of the leaves to the border mask in a couple of places to hold them still while you apply color. Remember to place your leaves so that the stems do not lead your eye out the corners.

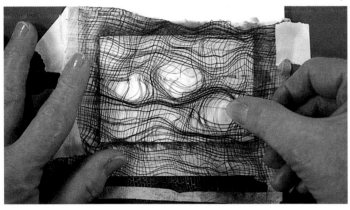

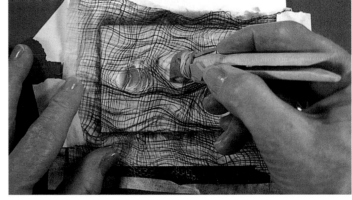

1 | **Push and Pull**
Cut off about 6-inches (15cm) of Sinmay ribbon; you will need just one piece. Push and pull the threads both vertically and horizontally to give an interesting knothole effect. Remember to strive for variety in size and shape of openings. Pull out some threads if you like.

2 | **Color in the Holes**
Arrange your pulled material in your window, placing your focal point just off center. Tape the Sinmay in place to the border mask. Think about your color scheme and choose your contrast color for your knot "holes." With your dauber or sponge apply color in the knotholes. Try leaving a white halo around them to emphasize their importance or combine other stencils with the Sinmay.

3 | **Finish and Blush**
Use your main colors to fill in the background and blush in the edges. Remove your card from the mask, title and sign. You might add a touch of stencil design to your envelope. Its smooth surface goes through the mail very well.

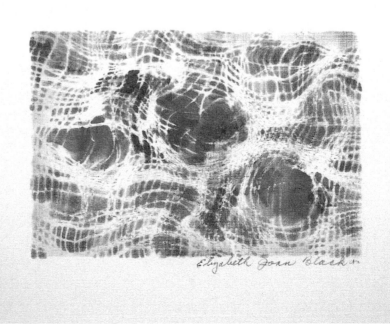

Using Transparent Masks

Acetate Mask

A transparent mask opens up all kinds of possibilities. It enables you to place a small design just where you want it on your card. A very good material for making transparent masks is 3-mil acetate which is sold by the foot or meter in art stores and used mostly for protecting student art projects. A piece of plastic sheet protector will also work. You can cut small windows in both of these materials with a craft knife or scissors. Remember to make your whole mask 1-inch (3cm) or so bigger than your window to fully protect your card from ink smudges. Mark the top side of the mask with tape to keep it right side up.

Tinted Plastic Mask

If you can find a suitable weight of tinted plastic—possibly report holders or plastic envelopes—it will help you to see exactly where you will be placing your mask opening and it is easier yet to find on your desk. You will likely have to use a craft knife to cut the tinted plastic. Mark your mask with a piece of tape to indicate which side is up, so you can keep the clean side toward your paper.

Cutting Circle Shapes for a Negative Stencil

If you have a paper hole puncher, try making circular openings (negative stencils) so that you can add lively dots to make your compositions sparkle. The 3-mil acetate is crisp and cuts beautifully with circle punches. If your punch won't cut the sheet protector cleanly, try sliding a piece of typing paper in with your plastic as you punch. The heavier report folders and plastic envelopes will usually cut with a $\frac{1}{4}$-inch (.6cm) punch or smaller, but are too heavy for larger punches.

Using a Small Square Mask and Dot Stencils

Try using some leaves in your small square mask along with your dot stencils to design a card. You can use pen flourishes to pull your elements together. You might even create an uneven number of varied hanging decorations that you can imagine are swinging from an overhead branch, like wind chimes. Before you try flourishes on your card, practice them over and over on large pieces of scrap paper. They must look elegant, smooth and flowing to make your card sing. Find your best position and try flourishing on a card-sized piece of paper. Keep turning the paper so that you can repeat the hand position that gives you the most graceful flourish. When your flourishes are smooth and graceful move to your card. Practice in the air a few times and then go for it!

Recycle and Reuse

Even fragments and trial pieces may hold hidden promise.

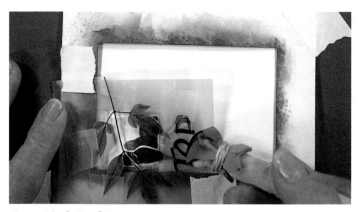

Create Lively Leaf Patterns
In the middle of a piece of tinted plastic or acetate about 3-inches (8cm) square, cut a small hole about 1$\frac{1}{4}$-inch square (3cm). The shape may be slightly relaxed to give your work a looser appearance. Slide your card into the regular $\frac{3}{4}$-inch (1.9cm) masking frame. Tape your leaf or stencil object on top of the mask with transparent tape so that you can see through the mask. Or you might try arranging your leaf, cheesecloth or other stencil object under the mask to hold it in place. Place your stencil where you would like it on your card and press your color around the leaf with a dauber or sponge. Repeat as necessary. When you lift your mask and stencil you may find the edges of your square need blushing in to complete the border. When you have finished with the leaf, remove it from the stencil and use the mask alone to blush in the edges.

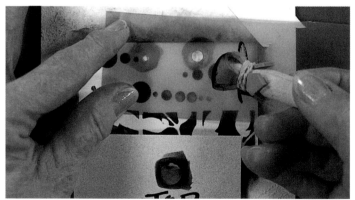

Add Dazzling Dots
With your dot stencils you might make an uneven number of varied hanging decorations.

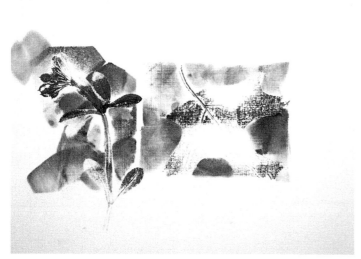

You May Need to Give First Aid

There was a bit of distracting white in the upper left corner which I blurred out with a dauber and light blue ink.

Look for Possibilities in Rejects

I nearly threw out this reject trial paper until I put a viewfinder over it and found a lovely composition just waiting to be discovered.

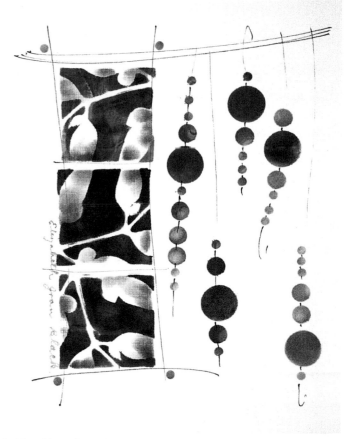

Finish with a Flourish

Connect the elements in your design with free flourishes of a fine-point pen, such as a Micron .01 pen. Do not be alarmed if your pen skips. Your eye will carry the line through, in fact you need some places where your viewers can allow their imagination to fill in what the line would look like. Although I have cautioned you to stay out of the corners, you might like to experiment with tiny dots of color right next to your flourishes at the corners of the panels.

>>> This card was made in a heart-shaped mask.

Swinging heart • Elizabeth Joan Black • Stamp pad ink and Micron pen on linen card stock • $5^1/_2$" × $4^1/_4$" (14cm × 11cm)

Folding your card paper lengthways to create a card that will fit in a standard no. 10 envelope.

Hanging by a Thread • Elizabeth Joan Black • Stamp pad ink and Micron pen on linen card stock • $8^1/_2$" × $2^3/_4$" (22cm × 7cm)

Betty Locke made this point about her yogurt lid stencils, "I find the enhancements with a pigma pen make the stencil just a jumping off point for a lot of things. I also like the fact that the beasts can face each other because of the duality of being able to use both sides of the lid."

Pachyderm Parade • Betty Locke • Yogurt lid stencil and embellishment with watercolor and pigma pen • $4^1/_4$" × $5^1/_2$" (11cm × 14cm)

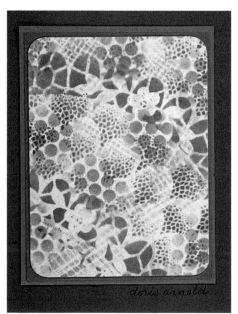

Doris Arnold used closely related colors to enhance the rhythmic patterns in her piece.

Chantilly • Doris Arnold • Stamp pad ink on card stock • $5^1/_2$" × $4^1/_4$" (14cm × 11cm)

Gallery

Betty Locke said while she was experimenting with this piece, she enhanced the image especially around the detail of the eye. She added eyes to the spaces she has left to give the beasts a bit of character, and when applicable she added a little point of paint to make pink noses. Whiskers for some are also neat and again add character.

Hanging Out Together • Betty Locke • Yogurt lid stencil, watercolor and pigma pen • $4^1/_4$" × $5^1/_2$" (11cm × 14cm)

Betty Locke emphasized individuality amongst her llamas with the placement of their black eyes and the variation in their blanket designs.

Llamas' Pajamas • Betty Locke • Yogurt lid stencil, watercolor and pigma pen • $4^1/_4$" × $5^1/_2$" (11cm × 14cm)

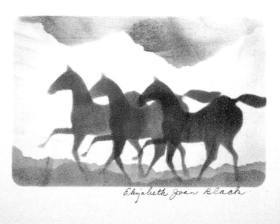

I pressed the fern leaf onto the stamp pad and then taped it, ink down, against the card. I pressed the sponge, inked with a contrasting color, on both the fern and the background. I liked the white areas that were saved in the composition by the thickness of the stems and leaves.

Forest Fern • Elizabeth Joan Black • Stamp pad ink with leaf stencil on card stock • $4^1/_4$" × $5^1/_2$" (11cm × 14cm)

I cut the stencil with scissors and refined intricate areas by cutting with a craft knife. I also defined the horses' heads with patches with masking tape, enhancing the shape I had initially achieved with the scissors. This technique takes some planning because you have to stencil with the negative shape (the part remaining) and we seem to be more apt to think in terms of the positive shape (the part taken out). However, once made, the stencil can be used over and over in many different ways and it will last indefinitely.

Wild Horses • Elizabeth Joan Black • Stamp pad ink using yogurt lid stencil on card stock • $4^1/_4$" × $5^1/_2$" (11cm × 14cm)

poor man's
AIRBRUSH

Poor Man's Airbrush is a simple and inexpensive technique that stands beautifully on its own or can be effectively combined with the stencils from the previous chapter. The setup is the same, but instead of pressing the sponge over the stencils, you will be lightly brushing on color with a sponge or dauber. Position your card in its masking frame as for stenciled cards (see pages 46-47). Practice this technique with one stencil first and see how much variety you can achieve with your cards.

[MATERIALS LIST]

⊚ Bright white card stock to give you the most vibrant colors

⊚ One or two multi-colored stamp pads either dye-based or pigment-based

⊚ Half dozen or so cosmetic wedges made of plastic foam or daubers (as used in stencil techniques)

⊚ Card-sized border masking frame cut to give a border to your design (as used in stencil techniques)

⊚ Pieces of cover weight paper about 5" × 8" (13cm × 20cm) which you will tear or cut into your own stencils

⊚ Masking tape

⊚ Page from a magazine for making two-part stencils

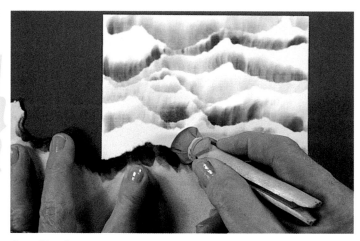

Start Simple

First try airbrushing on a scrap of paper until you have it working for you. Tear a strip of card stock into an edge that could be a horizon stencil. Load your sponge or dauber lightly with ink. Hold the horizon stencil strip securely on top of your scrap paper. Press your sponge onto the stencil and brush upward onto your scrap paper, lifting off about $1/2$-inch (1.3cm) from your horizon edge. Hitting the stencil first gets rid of the dark spot where the sponge contacts it and enables you to achieve a soft gentle sweep of color on your scrap paper. Aim for an even airbrushed effect. Now move your horizon stencil down $1/2$-inch (1.3cm) or so and repeat the airbrushing with a different color. Lift your sponge to leave some white spaces between your lines of airbrushing. When you can make soft lines of airbrushing separated by white spaces, then try adding more color in some areas. This will teach you how to bring up the color intensity when you make your cards. Try tipping your stencil to get variety in the spaces between your horizon lines. When you feel happy with your results place a card in the masking frame and begin.

DESIGN HINTS

⊚ Test your color on a scrap of paper before putting your sponge to the stencil.

⊚ Load your sponge lightly at first.

⊚ Work from light to dark—you can always add more color.

⊚ Leave white spaces to give sparkle.

⊚ Achieve unity by repeating colors.

⊚ Achieve variety by varying shapes and sizes of color areas.

⊚ Enjoy the special effects you can achieve by blending colors.

Sensational Scenes *with* a Single Stencil

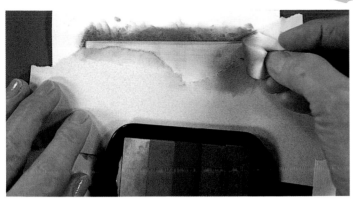

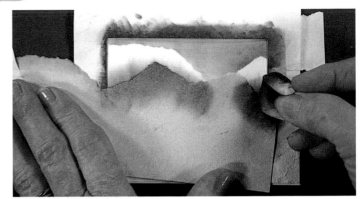

1 | **Brush on the Sky**
Tape your masking frame—with your card in it—to your table. Check to make sure your card will open the right way when you are finished. Tear lengthwise down your strip of stencil paper, creating an interesting horizon of peaks and valleys as you go. Choose one of the strips to be your horizon stencil. Lay it across the window in your mask—near the top of your card—to define your sky, and tape the stencil to your work table. Lightly load your sponge with color for the sky and test it on a scrap paper to make sure it is not too dark. Press your sponge on the side of the masking frame and drag it across the exposed card to create a sky effect. You may have to hold the top of the masking frame down with a spare finger and brush in from both sides to complete your sky. If you get a dark streak, blend it into the rest of your sky.

2 | **Move on to the Mountains**
Remove your stencil strip. Notice the subtle edge left by the torn paper stencil. Move your stencil down a bit and sideways. Aim for variety of thicknesses in your bands of color. Vary the shape above the stencil, thin to thick, chunky to skinny, by adjusting the angle of your stencil. Now the main airbrushing begins! Load your sponge, hold the stencil firmly, press the loaded sponge on the stencil and brush upward on your card to give a wispy, shaded effect. Lift your sponge before you touch the area of color above it to leave some white spaces. Repeat all along the torn edge. Accent some areas by pressing harder, making them more intense in color. Blend your colors.

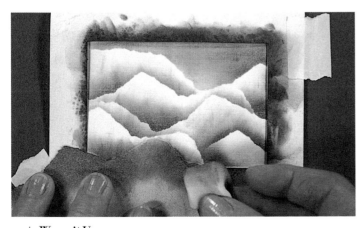

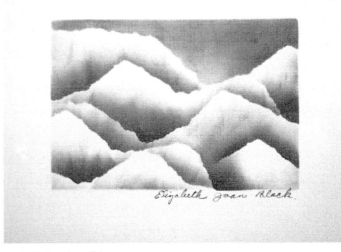

3 | **Warm it Up**
Use a different part of your stencil and change the angle as you move down the card. Enjoy blending the colors to produce vibrant effects. To create the illusion of distance, move into warmer colors as you approach the bottom of your card. If there are any blank spots on the edges of your composition, blush them in with pale ink so your border will be distinct.

4 | **Enjoy Your Edges**
Enjoy the airbrushed edges that would be impossible to paint with a brush!

55

Abstract Atmospheres

Try using a variety of torn stencils in one composition to make air-brushed landscapes and abstract designs. As a bonus the torn edges of your stencils, covered with color, make interesting bits to add to your recycle bin for collage. If you use torn blotting paper for a stencil you will get some spectacular, textured edges that may lead to a whole new direction in your art.

Using Cut Edges

Instead of tearing stencil strips, try cutting with your scissors to create interesting edges. You might consider making a four way stencil by cutting a different edge on each side of a large square piece of card stock.

Cutting out Shapes for Stencils

Try folding a piece of card stock and cutting out shapes such as baubles, in the way you would cut out a heart. You can use either the cut-out shape, the opening as a stencil or use a combination of both. Experiment with all sorts of combinations of edges. Remember to vary the values of your colors. Begin with light values and work up to very dark values to make your cards come alive. Leave some white area to give sparkle and contrast.

Turn Your Card Around

Keep turning your cards around to see if they look more interesting upside down or on their sides. You can always cut and remount your panel to adjust it to show its best side. Try combining your stunning stencils with Poor Man's Airbrush. Because the surface remains flat and smooth, Poor Man's Airbrush is useful as a background for calligraphy, stamping and sketching, and will go through the mail easily when used to decorate envelopes.

1 | Use Both Edges

Tear a horizon stencil from a magazine page. You will be using both the horizon side and the sky sides of the stencil, so the printing helps you to match up the edges. Arrange the horizon part of your stencil as before to airbrush in your sky. If you would like to have the sun rising (or setting), punch or cut out a sun shape from a small piece of paper or acetate. The piece that comes out of your punch, the circular sun shape, is the positive stencil. The remaining piece of paper or acetate containing the opening is your negative stencil. With your finger hold your positive sun stencil on top of the horizon stencil just where you want part of the sun to show. Blush some sunrise or sunset rays in the sky around the sun shape.

2 | Let the Sun Shine

Keep the mountain mask in place but remove the positive round sun. Place the negative sun stencil over the spot you have kept for the rising sun. With your dauber or sponge, press in the color for the sun.

3 | Islands and Trees

Cut in from the edge of a piece of a magazine page to make an island stencil. The lines of print will help to keep your water line level, and you can line up the magazine edge with the edge of your masking frame to help you. Can you guess how to make the reflections of the island? You will turn your stencil over and leave a very tiny space to give the shimmer at the shoreline. Cut out one or two tiny tree shapes in a small piece of paper and use it as a stencil to add some vegetation to your land.

4 | Distant Mountains and Details

Set aside the horizon stencil. Find the part of the torn-off strip that matches your horizon and place it over the sky to cover it. Tape the sky stencil in place, and airbrush down to form your distant mountains or hills. Where the torn edges do not exactly match you will have white shapes which look like light hitting the mountains. Decide on your far shoreline and use a straight edge of paper to airbrush in the trees on shore. Be sure that your shoreline is either above or below the middle of your composition so that your picture does not "flip over" when you look at it. Cut out a foothills stencil and airbrush it in to give a connection between the shoreline and the mountains. With your island and tree stencils, add some details to the foreground.

5 | Add Some Shimmer

Remove your card from the mask and evaluate it. Repeat the color of the sun and add some shimmer to the water by gently brushing in some sun color where it would show across the water. Replace your card in the mask and finish the water with soft strokes of colors you might see in the lake. You can even create the moon by using both parts of your sun stencil together to make whatever phase you would like.

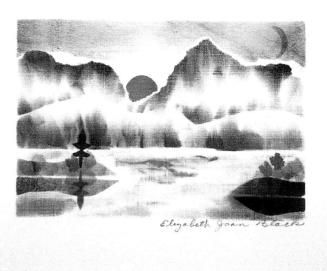

Elizabeth Joan Black

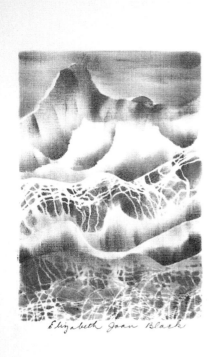

<<<

In this piece I combined stencils with the Poor Man's Airbrush technique.

ROCKY MOUNTAIN SUNRISE • Elizabeth Joan Black • Multi-colored stamp pad ink on linen card stock • $5^1/_2$" × $4^1/_4$" (14cm × 11cm)

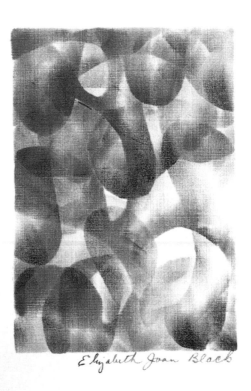

I airbrushed this piece using a single scissor-cut stencil of repeated waves.

ANATOMY LESSON • Elizabeth Joan Black • Multi-colored stamp pad ink on linen card stock • $5^1/_2$" × $4^1/_4$" (14cm × 11cm)

Gallery

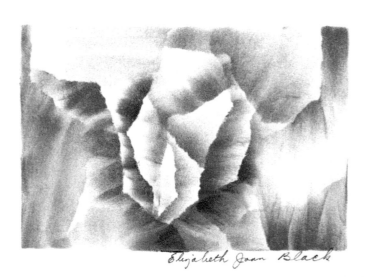

Elizabeth Joan Black

‹‹‹

I started working in the corners with large areas of muted colors, and built up the intensity of the shrinking shapes with more intense colors as I moved toward the focal point.

ENCHANTED CAVE • Elizabeth Joan Black • Multi-colored stamp pad ink on card stock • $4^1/4$" × $5^1/2$" (11cm × 14cm)

›››

With only two stencils—a torn piece of paper and a punched-out opening—Impi Sawchuk created a feeling of distance and peace with her sensitive strokes of color.

FAR HORIZON • Impi Sawchuk • Stamp pad ink on card stock • $4^1/4$" × $5^1/2$" (11cm × 14cm)

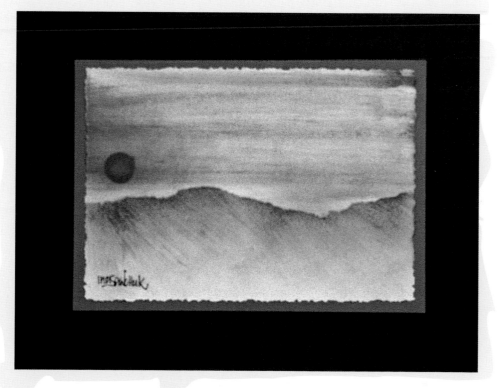

looking at
LAYERS

One of the great joys of my life was discovering the world of Oriental papers. The next time you are in an art store, ask to see the files or sample books of the fancy papers that are available. Their delicious thready textures and transparencies are hard to resist! Like me, you may soon find your under-the-bed storage space filling up with paper treasures. Watercolor seems especially suited to combine with the delicacy of Oriental papers. In this chapter we will look at layering tissue paper, cheesecloth, glue and paint as well as Oriental papers. Let's begin with a simple technique. There are several materials lists in this chapter specifically for the different types of collage.

One-Step Collage
Water-soluble crayons, with their intense colors, show through the thin Oriental papers when water and glue are applied.

[MATERIALS LIST]

- Pieces of card stock 3" × 3" (8cm × 8cm) or whatever size you prefer
- Water-soluble Caran d'Ache crayons
- White glue and glue brush or Acrylic Matte Medium
- Pieces of thin Oriental paper with threads in them. Each piece should be big enough to cover your composition.
- Squeegee—a strip of credit card or stiff plastic about ¼-inch to ½-inch (about .6cm to 1.3cm) wide
- Atomizer

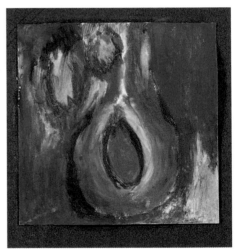

1 | Prepare to Be Amazed
Tear a piece of Oriental paper big enough to cover your card stock with some space to spare. Apply Caran d'Ache very heavily to your card paper. Aim for variety of shape, color and size in your composition. Blend colors. Be free in your design because it will change when you apply the Oriental paper.

2 | Gooey Glue
On your gluing magazine squeeze out some white glue. Dip your glue brush in water, then in the glue and brush the mix over the Caran d'Ache. You will find that the colors will blend. You may have to wash your glue brush out when going from light to dark areas to keep the light colors clean.

3 | Paper Pizazz

Center the Oriental paper over your wet piece and press it down. If you would like some cloudy white areas, put a piece of waxed paper over the Oriental paper to protect it and press all over the piece with your fingers. If you would like more color showing through, spray the top of the Oriental paper with an atomizer to make the Caran d'Ache bleed through more. Cover with waxed paper and press as above. When you are pleased with what you have, wrap the piece in waxed paper and put it in your press to dry.

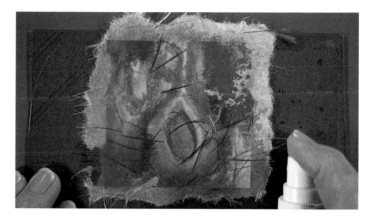

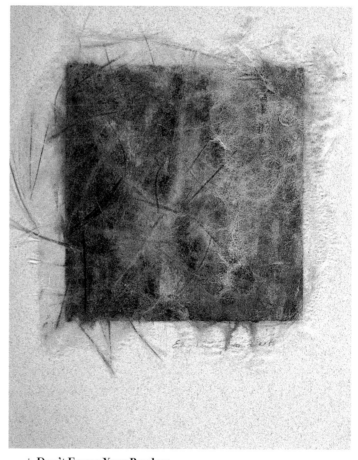

4 | Make Your Excess Exit

When your piece is dry, trim off the excess Oriental paper and mount on card stock. You might like to accent it with a metallic pen border.

5 | Don't Frame Your Borders

If you think the edges of your piece look attractive as is, leave the extra fancy paper showing and enjoy the effect it gives!

Collage with Cheesecloth and Plastic Added

Metallic plastic paint, net-like fabrics and tiny found objects placed over a watercolor base can give you striking results. Here is one way to proceed.

When you approach your blank square of paper you need to have some plan of how to apply paint as a starting point for your composition. Many watercolor artists try to have different background shapes at the corners of their paintings to give interest. In this demo I have painted five bites out of the edges of the paper, starting with the corners and adding one more. You might try three, four, five or so bites to start you out. Aim for variety in shape and size of bites.

1 | **Start to Shape**
Choose a color that you like and mix a puddle of paint. With your ¹/₂-inch (13mm) chisel brush, paint a different shape coming in from each corner and one edge of your 6-inch (15cm) square of paper. Strive for an intriguing shape to build upon.

2 | **Go Crazy with Contrasting Colors**
Use your ¹/₂-inch (13mm) chisel again to add contrasting colors to your middle shape. You might like to leave some streaks of white showing along the edges to add liveliness. Be free and daring as you apply your paint as most of your painting will be changed as you keep on working.

[MATERIALS LIST]

- Watercolors in tubes or pans and a ¼-inch (13mm) chisel brush
- Metallic fabric paint or inks
- Pieces of white card stock about 6-inches (15cm) square so that you have some leeway in finding suitable compositions within your piece
- White glue and a stiff glue brush
- Small torn pieces of thin Oriental papers in whites and neutral colors. For collages, paper containing threads is particularly lovely to work with.
- Woven cheesecloth
- Squeegee
- Ruler, metallic pen, pins and viewfinder for mounting

3 | **Squeeze and Squeegee**
Squeeze some metallic fabric paint onto the interior shape. Move the paint around with your squeegee to create interesting shapes. Let it dry completely.

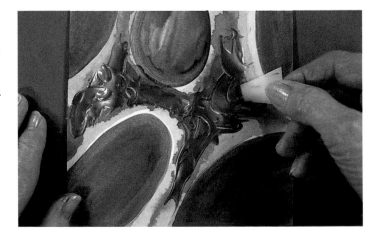

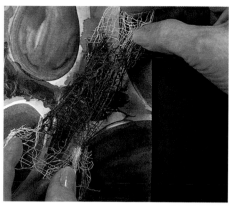

4 **Paint Your Cheesecloth**

Squeeze some white glue onto your gluing magazine. Beside it, make a puddle of intense watercolor paint. With your glue brush, stir the two together into a smear of color. Cut a piece of cheesecloth, Sinmay ribbon or netting into a piece bigger than you will need for your collage. Press the middle of the cheesecloth into the paint and saturate the fibers by pressing on it with your brush. Lift the cheesecloth by the clean ends and move it to your composition. Set it in place and cut off the extra. With a piece of plastic wrap, cover the glued cheesecloth and press it firmly in place with your fingers. Remove the plastic and let your piece dry.

5 **Visualize Your Composition**

Try several sizes of border guides to see if you can find some interesting compositions in your piece even before you add more to it. Look for focal points. Arrange your composition so that lines do not shoot out of the corners.

6 **Cut it Out**

You'll be able to cut out your composition accurately by joining the pinholes on the back of your work.

7 **Harmonize with the Border**

Try your piece on several different colors of card stock to see what background enhances it. A very narrow undermat in a color that echoes a color in your composition will harmonize your art with its border.

8 **Other Ideas**

Enjoy all the texture and contrasts you can create with your art materials. Aim for some quiet spots to accent the highly textured parts. Let your piece dry. Again use your masking frame to choose a composition that is pleasing to you. Mount on paper that complements your piece, then title and sign it.

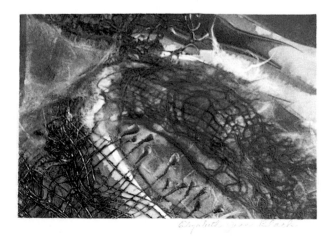

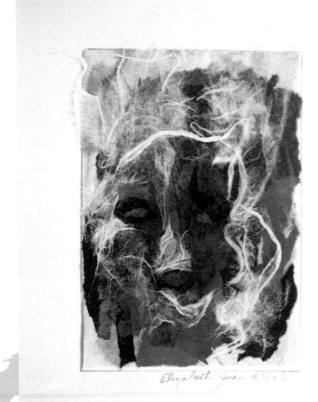

<<<

I drew a border using my guide and a gel pen, and painted a free wash of light-colored watercolor inside the frame to soften the background. I applied torn pieces of tissue smoothing them down with a glue brush and diluted white glue. A face began to emerge. I developed the face a bit and gave the bride a veil of Oriental paper.

VEILED BRIDE • Elizabeth Joan Black • Watercolor, colored tissue paper and Oriental papers • 5$\frac{1}{2}$" × 4$\frac{1}{4}$" (14cm × 11cm)

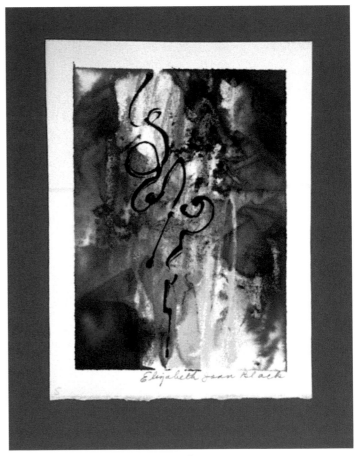

The center of this piece needed more drama than the crayon and watercolor provided. I practiced some calligraphy-like flourishes on scraps of paper using the needle-nosed applicator of the fabric paint until I could squeeze and flourish at the same time!

BLUE CALLIGRAPHY • Elizabeth Joan Black • Wax crayon, watercolor paint and slick fabric paint • 5$\frac{1}{2}$" × 4$\frac{1}{4}$" (14cm × 11cm)

<<<

Donna Livingston used a wash of pearlescent paint over the water-color paint to give a subtle sparkle to her purple paper.

AMBROSIA • Donna Livingston • Mixed media collage on card stock • 6⅝" × 5" (17cm × 13cm)

TRANSFORM A MINISCAPE WITH COLLAGE

If you have a miniscape that needs a lift, try adding some collage elements to it!

LIGHTNING STRIKES • Joan Adams • Watercolor on 90-lb. hot-pressed paper • 4¼" × 5½" (11cm × 14cm)

FLOODWATERS • Joan Adams • Watercolor, tissue paper and Oriental papers • 4¼" × 5½" (11cm × 14cm)

Joan Adam's piece started out as a miniscape with a blue sky at the top. She inverted the composition and mounted it, but saw that it needed some changes. The painting lacked a focal point and needed details in the center of the work to make it succeed. The torn paper undermat she used at first was too wide and dark for the painting and the thready edges drew the eyes of the viewer away from the composition. The piece, however, had excellent potential for collage. There were sparkling white spaces left and interesting subtle patterns of color to capitalize upon. Joan decided to use collage to bring the composition to life.

Joan Adams gave the painting a haircut by removing the thready, overpowering undermat. She decided to keep the two small red and white shapes at the right as a focal point and balance them with heavier, dark collage of trees on the left. She was careful to place her waterline below the middle of the painting and to soften it with torn pieces of light-colored Oriental paper. Bits of red tissue shine through. Joan re-mounted the work to place her signature more gracefully, and chose burgundy paper to bring out the richness of the revitalized composition.

the charm of the
CHISEL BRUSH

The 1/2-inch (13mm) chisel holds many possibilities for creating exciting designs beyond its use in regular watercolor painting. In this chapter I will share with you several ways of using your chisel brush in a calligraphic fashion, emphasizing the lovely thick and thin lines that you would form in writing words.

Practice in Short Sessions

Writing is a skill that requires repetition to learn. Similarly, making graceful strokes with your chisel brush requires repetition and practice. So don't be discouraged if you find that making some of the strokes is difficult at first. A few minutes of concentrated practice every day will help you to improve your style. Working in long sessions can be counter-productive, as it is hard to learn a skill when you are tired. Change to another activity if you find yourself getting worse instead of better. Try to make every stroke your best so far, so that you establish the graceful shapes in your mind and your hand. You want to practice your best strokes. A good night's sleep will often yield encouraging improvement!

Capture the Essence

Chisel brush painting is not so much concerned with realism as it is with conveying the essence. Capture the general idea of a flower, an animal or object in a few strokes of the brush. Learning how to make a few strokes really well will enable you to create many attractive designs. Canadian artist-calligrapher Betty Locke has been largely responsible for opening my eyes to the possibilities of the chisel-edged brush.

Getting Ready to Paint

Practicing the strokes of chisel brush painting requires concentration. Start out right by setting up a comfortable work space. Gather all the materials you are going to need so that they are ready to go before you begin to paint. Soften your watercolors by spraying them with water. Have a place ready to dry your finished sheets and

[MATERIALS LIST]

- 1/2-inch (13mm) chisel Aquarelle brush with an excellent, even chisel edge. A good brush is a must. The bristles should be no longer than 5/8-inch (1.6cm).
- Watercolor in pans or tubes. These cards were made with an eight color set of Prang school watercolors in pans.
- Two containers of water—one for rinsing your brush and one for clean water. Remember to use a container with slots in the rim to store your brush up and out of the water when it is not in use.
- Two dozen sheets of bond paper or light bristol card stock cut to 8½" x 5½" (22cm ×14cm) so that you can turn your sheet around as you practice your strokes
- Scrap paper for testing your brush strokes
- Protractor or a good eye for 30°
- Fine-point pen, such as Micron .01

a work area where you can comfortably rest your arm and wrist on the table for support.

Double-Load and Test Your Brush

Dip your brush in your clean water jar and wipe each side of the brush once on the rim. Choose two of your favorite colors and double-load your brush (that is rub one corner of the brush in one color, and the other corner in the second color). Right away you can have the fun of painting in your favorite colors! Make a short, wide stroke on your test sheet to see how the stroke is working. If the stroke looks too juicy and watery, make a few more strokes to dry up the brush. If it looks too dry or the bristles split, touch the brush to the water and test again until you get a satisfying even stroke that you can control. Use your test sheet each time you reload your brush until you feel confident to judge from experience.

Try Some Warm-Up Strokes

These first strokes do not require you to twist or angle your brush, and yet enable you to create several interesting designs.

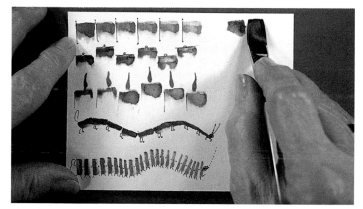

Simple Pats Do the Trick

Double-load your brush and test it on your scrap paper. Now hold the brush quite flat and press the side of the bristles down on the paper. Lift and repeat. Later you can add a few pen lines and make your marks into flags, pots, candles and so on. Try varying the width of your mark and create curved patterns that will turn into caterpillars, centipedes and other creatures.

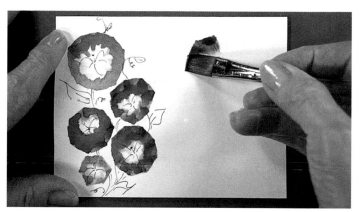

It's a Beautiful Morning

Double-load your brush, test and pat it to make a circle, connecting the outside edges. Move your piece of paper to help you with each stroke. Vary the size of your morning glory flowers. When the flowers are dry, pull your design together with some connecting stems, leaves and tendrils using your fine-point pen.

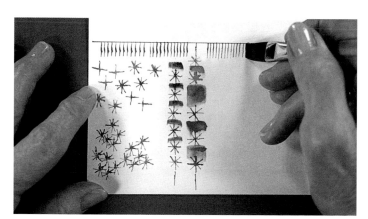

From Thin Lines to Stars

Prepare your brush to paint and rest your wrist and forearm securely on the paper as though you were going to write. Hold the brush nearly straight up-and-down and place it at a 90° angle to the horizontal line. Touch the ends of the bristles to the paper to form the thinnest lines possible. You will likely have to tip your hand in toward your body, supporting it with your little and ring finger. Make a dozen or so thin-touch strokes like a fence. When you can make thin, even strokes, try lifting your hand and making touch strokes in different positions to form stars. Experiment with a combination of patting and touch strokes to make baubles.

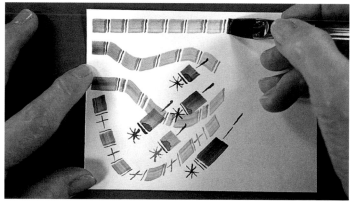

From Thick Lines to Bamboo and Borders

Start with a thin-touch stroke and pull it to the right to make a thick stroke. Alternate thick strokes and thin-touch strokes to make a border pattern that looks like bamboo. When you can do this, try bending the bamboo and combining strokes that you have just learned to make designs and borders.

Beginning Calligraphic Strokes

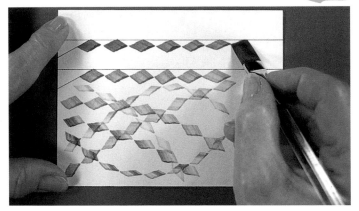

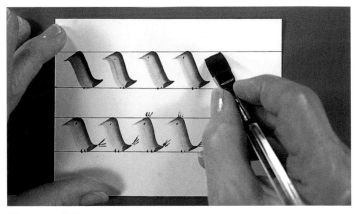

Begin at a 30° Angle

Draw a couple of horizontal, straight lines as guides on your paper. Estimate or measure with a protractor a 30° angle down from the horizontal line and mark it on your paper. Now set the angle of your brush to about 30° from the horizontal line. This is a comfortable angle for writing often used by calligraphers. The gracefulness of calligraphy comes from keeping the brush at the same angle all the time. Touch your brush to the paper and pull down and to the right to form diamonds, keeping the same 30° angle all the way down. When you can make a straight garland of diamonds, try curving your garlands. Remember to leave a tiny white space between the diamonds to let them breathe. Your eye will enjoy connecting the shapes.

Birds on a Wire

Draw parallel lines about 3/4-inch (1.9cm) apart on your paper. Set your brush at 30° (as for garlands). Slide up and to the right a tiny bit to make a beak on your bird. Then pull down at 30° to the wire. Keep the back of the bird straight. As you touch the bottom wire, keep the same angle on your brush and curve up and to the right, again at 30°, and lift off to end the body. Check your angles by turning your paper upside down. Your birds should look the same from either way. This is your first truly calligraphic stroke and it will require practice to make it elegant. If you are satisfied with your birds then move on to the next step. If they could use some grooming take a break or a nap and try them again when you are refreshed. Work slowly and keep the lift-off for the end of the body slow and controlled. Most of us tend to finish up in a hurry and hope for the best! Enjoy adding eyes, feet, tail feathers and crests with the corner of your brush to give your birds some character.

Pairs on a Wire

Again draw parallel lines to guide you. Turn your paper so the lines are going vertically. For the bird facing right, start with a body stroke at 30° and pull up to finish with a beak also at 30°. This is a tricky stroke and again will require practice. You will turn your page back to the horizontal way to make the left-facing bird.

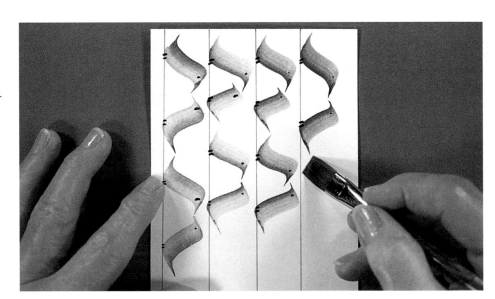

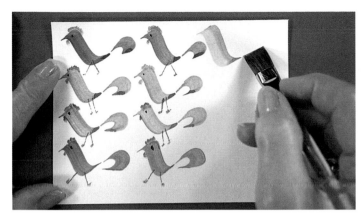

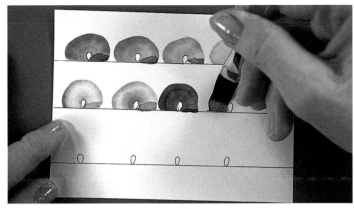

Rowdy Rooster

Make your bird as usual but add a curved tail. Start the tail at the same 30° angle as you finish the body. Again leave a tiny white space to add some life to your rooster. Touch and pull to the right, then curve down to make the rooster tail. Lift off gracefully. This last stroke is hard to learn, but it is the basis for the petal stroke that can be used to create a variety of flower shapes.

Conquer the Petal Stroke

This is where a live demonstration is needed! Maybe I can help you to think of what you need to do in the petal stroke. The petal stroke is a straight stroke bent around so it appears to be standing with its head and feet on the ground. If you concentrate on the "seed shape" inside the petal, the outside edges of the stroke will take care of themselves.

First draw some seed shapes on the straight horizontal line. Double load your brush. Place your brush on the horizontal line at the bottom of the seed shape (that's at 0°) and try to go all around the seed and back to the line in one stroke as if you were painting a rainbow. I know this can be difficult, but take heart, the petal stroke is easier! Your double-loaded brush will tell you when you have the rainbow right, that is when the same color follows your seed shape all the way around.

When you understand the rainbow you will find it much easier to start and end the petal stroke at a 30° angle instead of starting and finishing at 0°. Let's make the change using some guidelines to help you.

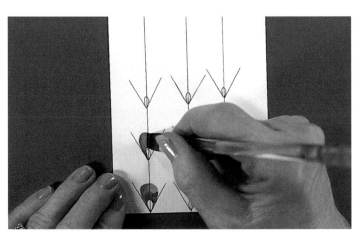

Gain Confidence with Guidelines

Draw several parallel lines on your paper and draw in guidelines for the 30° mark on each side of the lines as shown. You can also draw in the seed shapes for the first few strokes if you like. Set your paper at a comfortable angle for you to make petal strokes. You might try vertical lines as shown.

Set your brush on the 30° guideline as shown. Keep your eye on the seed shape in the middle of the petal. You will draw the seed shape with the left edge of your brush. As you move over the middle line try to make a mirror image of the seed with the left edge of your brush. Lead your brush into the angled guideline with the left edge. Students often try to give the brush an extra twist at this point. Resist the temptation! Keep sliding in on your left edge and lift off at the end. Use a very light touch, paint with just the tips of your bristles.

This is an especially difficult stroke because you are doing two things at once—controlling both the right and left sides of your brush while they are both moving. It is something like patting your head and rubbing your stomach at the same time! Take a break and come back to the petal later if you are feeling frustrated. It sometimes needs a few nights of sleep to succeed.

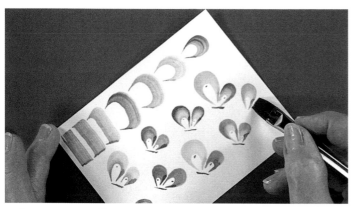

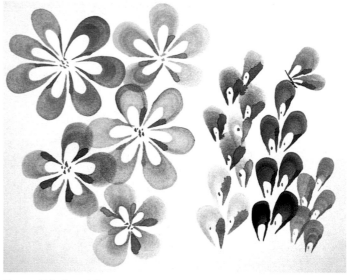

Make Your Butterflies Soar

Recall how your straight stroke becomes a petal. Use two petal strokes and a touch stroke for butterflies. Make sure that you keep using the ends of your bristles for the butterflies. There is not much substance to these insects. Let your strokes say that. Remember to leave some tiny white spaces between the elements of your butterfly so that it remains airborne!

Create Fabulous Flowers

As you paint the petals keep turning your paper to help you keep the strokes consistent. The petals do not have to be exactly the same but they should be enough the same to say "flower." Most importantly, the contrast between your thick strokes and thin strokes should be very marked. Add centers to your flowers with some dark paint and the corner of your brush, or with a metallic or black pen. It is a good idea to work on several small pieces of paper in rotation so that you are always adding to dry paintings. This way you will avoid smudging your work.

Relax with Larger Flowers

Of course you can create larger and smaller flowers with varying sizes of brushes. But by using your $\frac{1}{2}$-inch (13mm) chisel and relaxing your petal stroke, you can create large flowers with the brush in your hand. Start your petal stroke at the regular 30° angle, but as you pull into the wider part, wiggle your brush to make a large, floppy petal. Finish your stroke with the same elegant thin ending as before. If you load only the right corner of your brush you will get a soft transition to color in the middle of your flower which will give the suggestion of a pale throat. If you load only the left corner of your brush you will get the opposite effect. Try creating double flowers by adding layers of petals.

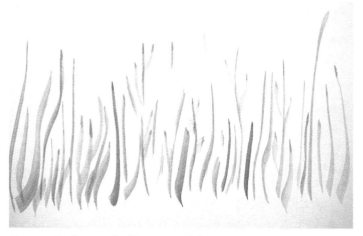

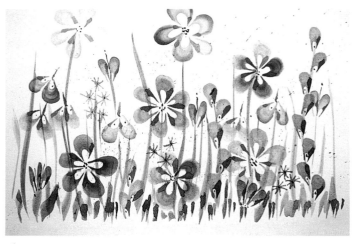

Create a Background of Leaves and Stems

You may find that you can add leaves and stems with your brush success-fully after you have painted your flowers. If that is hard for you, try making a background of foliage first in pale colors and painting your flowers on top. Your background needs to be loose and flowing, like a page of calligraphic flourishes. Practice in the air first! Then use scrap paper until you can make elegant thick strokes and thin strokes on your paper. Find the position that is best for you. Starting at the bottom, swoop up to the ends of the stems and lift off. Twist your brush to give variations in width. If your brush skips—let it be! Your eye will be happy to fill in the missing parts. Make several double sheets of foliage and choose the best part of one as a background for your flowers, or use the whole thing as a wrap-around card with flowers both front and back.

Flower Power

Look at your background and plan about where your largest flowers could go, there will likely be an uneven number of them. You can paint them at the tops of stems or overlapping stems. Overlap your flowers with each other to give them unity. Remember to turn your paper around to help you. Leave some white spaces between your petals to give an airy effect. If you have spaces in your composition, fill them in with tiny flowers. To give contrast add some darker leaves at the bottom of your panel. Add atmosphere with a spatter of paint over the finished flowers. To spatter, load your brush and tap it on your finger. Try it on test paper first! Crisp centers and little dots add vitality to your flowers.

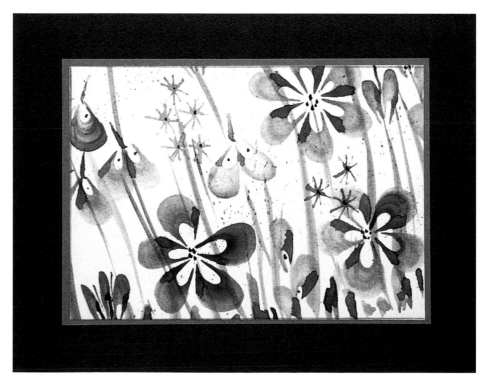

Compose Your Garden

An uneven number of large or bright flowers in your composition will likely be most pleasing. Mount your garden and enjoy! No weeds!

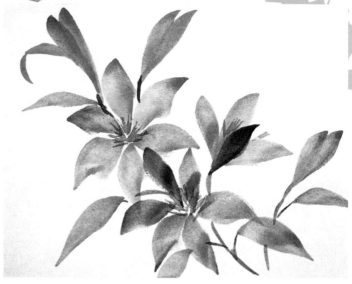

Betty Locke used her brush strokes to create a new species of birds.

STRICTLY FOR THE BIRDS • Betty Locke • Watercolor on card stock • $5^1/_2" \times 4^1/_4"$ (14cm × 11cm)

The air space between petals gives lightness to the flowers.

CLEMATIS • Betty Locke • Watercolor on card stock • $4^1/_4" \times 5^1/_2"$ (11cm × 14cm)

Betty Locke achieved variety here by showing the flowers at different angles and creating buds with just a few strokes.

DAISIES • Betty Locke • Watercolor on card stock • $5^1/_2" \times 4^1/_4"$ (14cm × 11cm)

Betty Locke draws in the viewer's eye by varying the height of her crocuses.

CROCUSES • Betty Locke • Watercolor on card stock • $4^1/_4" \times 5^1/_2"$ (11cm × 14cm)

Gallery

>>>
Contrasting thick and thin strokes brings these graceful flowers to life.

A FUSION OF FUCHSIAS • Betty Locke • Watercolor on card stock • 5¹/₂" × 4¹/₄" (14cm × 11cm)

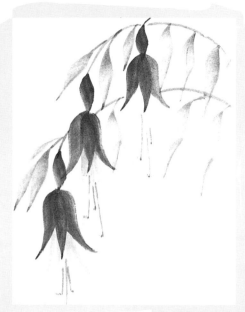

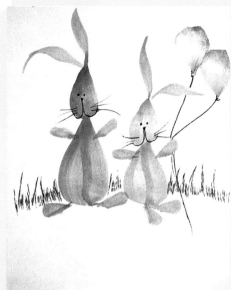

<<<
Much of Betty Locke's work bubbles with her sense of humor. She has invented many chisel brush interpretations of animal friends.

FUNNY BUNNIES • Betty Locke • Watercolor on card stock with pen embellishment • 5¹/₂" × 4¹/₄" (14cm × 11cm)

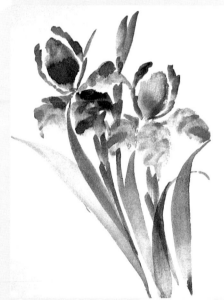

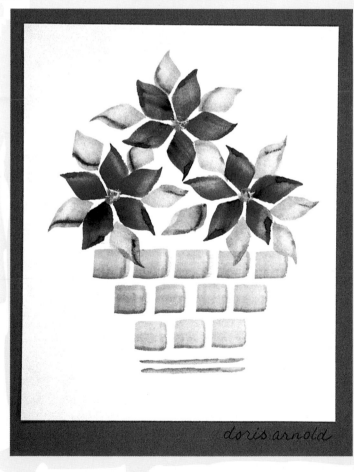

<<<
Doris Arnold shows how the brush can make baskets or flower pots as well as flowers.

BLUE POSIES • Doris Arnold • Watercolor on card stock • 5¹/₂" × 4¹/₄" (14cm × 11cm)

The light and dark colors in the flowers and leaves add a spark of liveliness to the painting.

PURPLE IRIS • Betty Locke • Watercolor on card stock • 5¹/₂" × 4¹/₄" (14cm × 11cm)

serendipity
PRINTING

Printing techniques hold a great fascination for the child in us all. There is always the surprise element in pulling off a print. Many types of plastic will work as a printing plate when sanded to give a "tooth" to hold the watercolor. Many types of paper will work with watercolor printing, but I feel that it is worthwhile to use professional quality paper.

Prepare Your Plastic Plate

First, cut the plastic pieces to your desired size and sand them. I use pieces measuring about $2^{1}/_{4}$" × 3" (6cm × 8cm). Acrylite used by professional printers requires a handyman or professional to cut it, but thinner plastics can be cut with scissors or a craft knife. Take your cut plastic plate outdoors (so that you don't breathe the plastic dust) and sand it lightly with a circular motion using a fairly fine (about 120 grit) sandpaper. Check that your plate has an all over cloudy look. Sand the corners so they are not hazardous to handle. Wipe off the dust.

Prepare Your Paper

If you are running a series of prints off the same sized plate, then cut all your paper to that size before you start. I use 3" × 4" (8cm × 10cm) pieces, which mount nicely on cards. Choose a paper size to work with your plate and remember that you need to allow space for a white border. Printing paper usually comes in large sheets so you will likely need a yardstick, a sharp pencil and good scissors—or a sharp craft knife and steel edge to cut your paper. Accurate cutting at this point will help you when you line up to print. If you use scissors, make short snips to avoid the notches left from the scissors tips.

Soak Your Paper

Your paper needs to be pre-soaked to give it time to absorb enough water so that it can pick up the watercolor from your plate. Soak the paper pieces for at least half an hour. I have left paper in the vat for several days without damage. When you place your paper in the vat, be sure that both sides get wet and that your hands are totally clean. You are looking for that clean, white border and a clean design.

[MATERIALS LIST]

- Watercolors in tubes, an inexpensive set of Pentel tubes works well.
- Caran d'Ache water soluble crayons
- Paper for printing such as BFK Rives or Stonehenge. These are both fairly heavy papers and absorb a good amount of water to pick up the dry color on your plate. Lighter paper such as BFK Lightweight and Oriental Masa paper will also give good results.
- Plastic for making your printing plate. Try whatever firm, smooth-surfaced plastic you have available, such as pieces of hard Acrylite, heavy plastic file covers, plastic envelopes from an office supply, yogurt lids, ice cream bucket lids, pieces of plastic milk jugs—any piece of smooth, firm plastic will work.
- One plastic sheet protector or a piece of stiff, clear plastic for a press bed, which is where you do your printing.
- Paper towels
- Old, cloth towel
- The heel of your hand or your foot for a press
- Vat (a shallow pan) for soaking your paper
- Sandpaper—about 120 grit (fine) for sanding the plastic
- Yardstick, sharp pencil, good scissors or sharp craft knife and steel edge for cutting up large sheets of printing paper
- Squeegee (you can make one from an old credit card) tiny brush, or toothpick (to move paint around on your plate)

Prepare Your Press Bed

The press bed is a clean, clear plastic surface on which you will do your printing. A plastic sheet protector works well. To make a guide for lining up your printing paper, use one of your cut printing papers. Roll a small piece of masking tape, sticky side out, and adhere it to the back of the paper. Slide the paper into the page protector, line it up square and secure it with the tape. I usually tape the sheet protector to a magazine to give a bit of cushion for printing.

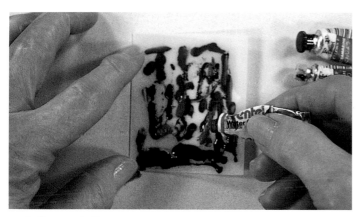

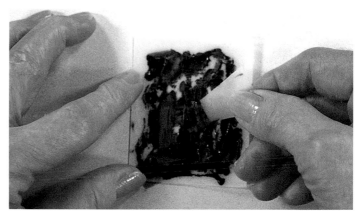

1 | **Squeeze it On**
Select a limited palette for this tiny composition. Apply enough paint to enable you to move it around freely with a brush, squeegee or a toothpick.

2 | **Paint Patterns**
You might make one flourishing stroke with your squeegee through the paint and look at your design. Did you make some interesting blends? What else does it need? If you squeegee too much you will end up with mud, so be a bit cautious. For a more delicate look, you might like to try pulling the color around with a toothpick or your tiny brush. Try to end up with a fairly even application of paint to give you a consistent printing job. When you are satisfied, set your plate to dry away from the sun (sunlight will likely make the paint crack and curl up). Set a half dozen pieces of paper to soak in the vat if you are going to print the same day.

PREPARATIONS FOR PRINTING

Printing is like working in a lab. You need to pay attention to technical details and cleanliness to be able to enjoy what you are doing and produce satisfying prints.

3 | **Add Caran d'Ache Crayon (Optional)**
You can add color directly onto bare places on the plate and over the dry paint as well. The bare places will be white areas in your print which can integrate the composition and its border. To give a definite edge to your design, rub the crayons along the edge of the plate.

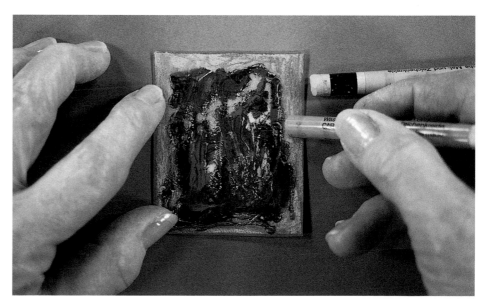

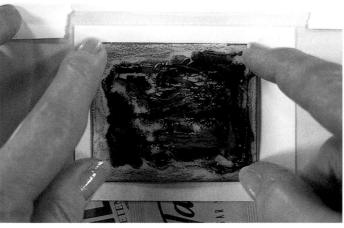

4 | Put Your Plate to Bed

Wipe off your press bed to make sure it is clean and keep checking that no specks of paint have gotten on it to mar your print or border. Roll a piece of masking tape sticky side out and attach it to the back of your printing plate. Hold your plate painted side up over the press bed. Look at your paper guide to help you place your plate, so you can print as planned. Aim for a border with three sides the same and more space at the bottom for signing. If you have a deckled edge it will likely go best at the bottom. Eyeball where your plate should be secured on the press bed using the paper as a guide. When you are satisfied press your plate down into position.

5 | Blot and Set Your Plate

Be sure your hands are clean. Pull a piece of soaked paper out of the vat and pat it between the folds of a cloth towel. Check that there are no shiny areas before your press it on the plate. Hold the paper over the printing plate and line up the top end carefully with the guide paper that's under the press bed. With your fingers, gently press the paper down on the plate to secure it in place.

6 | Give Your Card a Hand

To give a little cushion, place a paper towel or tissue on the paper. Then with the heel of your hand, apply pressure all over the plate. Even better you can place your press bed on the floor, take off your shoe and stand on the plate. The fleshy parts of hands and feet help push the printing paper into the valleys of paint and do a fine and inexpensive job of printing for these small pieces. For the first print you will not have to push very hard to get an impression. You will need to exert increasing pressure as the plate loses the watercolor.

7 | Remove Your Print

Hold one edge down and carefully lift up an opposite corner and peel your print off the plate. The first print will likely be dark. Let your plate dry for a few minutes and then you can print off it again.

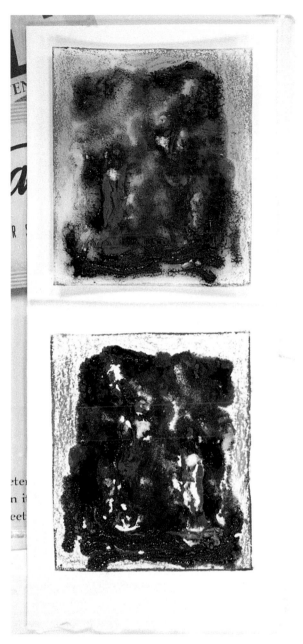

8 | Check Your Plate

When the plate is dry you can add more Caran d'Ache or paint, as you desire, to change your composition or you can leave it and see what changes occur as you print. The results will amaze you!

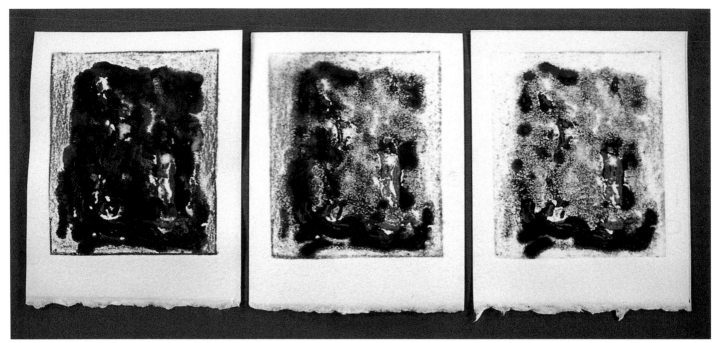

9 | **Go Ahead and Be Choosy**
Often the second print will come off clearer than the first. Because every print will be slightly different—even though they are from the same plate—these prints are considered monoprints and each one is numbered 1/1. If they were in a series of twenty prints exactly the same you would number them 1/20, 2/20 and so on.

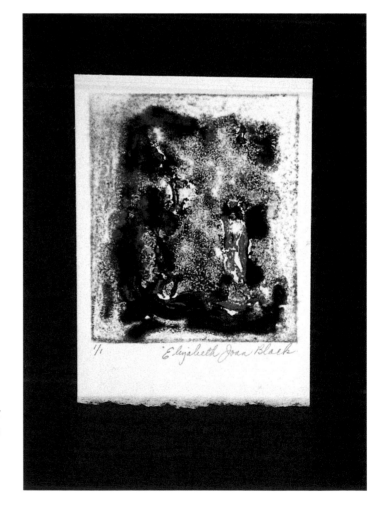

10 | **Look for a Name**
Choose a background paper that will complement the colors in your print. Even though these prints are designed very freely, fascinating shapes will often appear in them suggesting a title.

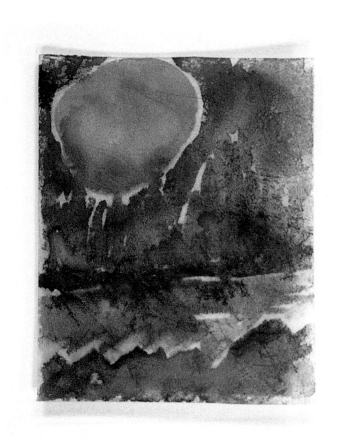

Reach for Realistic Results

Paint a more realistic composition on your plate with thick watercolor from pans or tubes. Let dry and print as before. You will notice that the brushed-on paint, being thinner, gives a softer pointillist effect and that the paint soon wears away. But then you can paint another plate.

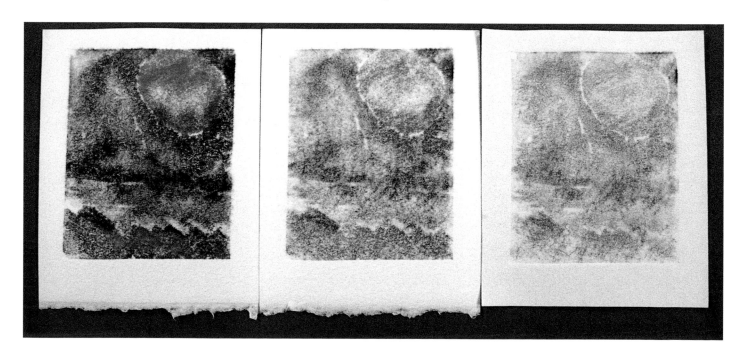

Ideas to Try

Try a Foam Tray

Cut your piece of tray to the desired shape. It is not necessary to sand the foam, because the crayons will bond with the foam as is. Press hard with a discarded ballpoint pen or a stylus to make your design in the foam. Remember that your print will come out as a white outline composition. Color the plate with Caran d'Ache crayons. Press hard for bright colors. Print as usual.

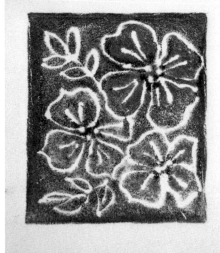

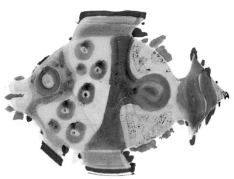

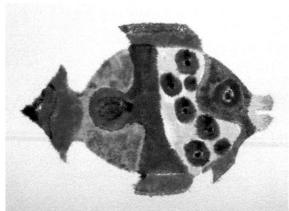

Shape Some Sensational Scenes

Use plastic envelopes or some kind of plastic that you can cut easily to make a shaped printing plate. I cut a fish out of a stiff plastic envelope for the plate. I laid it on top of white paper to add the design using water-based markers. The white paper helps you to see your design and color scheme. In this technique I like to use a "touch-me-not" approach, in which the colors are separated by a narrow space. This not only preserves your marker tips true to color, but it also gives a pleasing bit of white to your design. All the color is removed from the plate by one print. I printed the fish as usual using soaked paper.

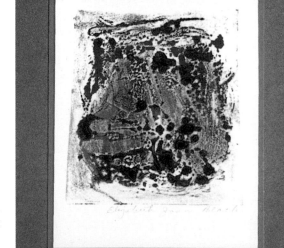

>>>
The paint was applied to the rough side of an unsanded, plastic envelope. This was a test piece that yielded a very organic design.

GEMSTONE • Elizabeth Joan Black • Watercolor print on BFK Rives paper • 5$\frac{1}{2}$" × 4$\frac{1}{4}$" (14cm × 11cm)

Gallery

>>>
The very narrow
undermatting in
this print effectively picks up
the color of the leaves
and stems.

Summer Blooms
• Lois Sander • Watercolor
print on 90-lb. (190gsm)
hot-pressed paper •
$5^{1}/_{2}$" × $4^{1}/_{4}$" (14cm × 11cm)

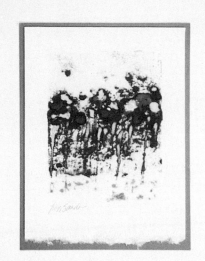

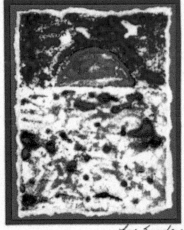

Lois Sander has placed the horizon well
above the center of her composition to create
pleasing proportions in her print.

Rising Sun • Lois Sander • Watercolor
on 90-lb. (190gsm) hot-pressed paper •
$5^{1}/_{2}$" × $4^{1}/_{4}$" (14cm × 11cm)

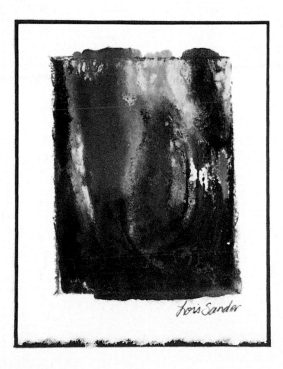

The intense colors and high contrast in this
piece shows us just how dramatic a small print
can be.

Firestorm • Lois Sander • Watercolor
on 90-lb. (190gsm) hot-pressed paper •
$5^{1}/_{2}$" × $4^{1}/_{4}$" (14cm × 11cm)

creative PAPER CASTING

For years I have searched for simple ways to make creative molds for paper casting. Most information I could find suggested using found objects, and some involved the making of latex and other kinds of molds. I have tried plaster molds and plasticine forms cast in plaster, but the easiest and most successful way I have found so far is to use craft foam to make the molds. I saw the way my husband, who is a potter, used the foam shapes to impress design in clay panels. I wondered if the foam might make impressions in wet paper.

Much to my delight I found that the foam worked very well. It's inexpensive and readily available at craft stores. It is easily cut with scissors, does not tear the freshly made paper and will indicate very fine lines. Paper casting requires freshly made paper in order to work, so the process is a bit involved but satisfying when you see the end results.

SCREEN AND DECKLE SET

You can make your own screen and deckle set with embroidery hoops or have someone specially cut a wood frame for you. The *screen* is a frame with a porous screen material stapled to one side for catching your paper fibers and forming your sheet of paper. The *deckle* is a plain frame, the same size as the screen, which sits on top of the screen and defines the edges of your paper sheet. For your screen use plain weave (not knitted) curtain material or voile. Secure the curtain material in one embroidery frame set to make the screen and use the continuous outer frame of the other set as your deckle. If you cannot find plain weave curtain material or voile you can also use fiberglass window screen as your screen material. It will however leave a screen texture on your sheet of paper that will show up in your finished work. I use a matching rectangular set of wooden strips with an inside measurement of about 3¼" x 4½" (8cm × 11cm). This makes a sheet of paper which fits on my standard card and leaves a border showing.

[MATERIALS LIST]

For Making the Foam Mold

- Craft foam sheet about 2mm thick. Choose light colors so that you can see your pen lines on it.
- YES glue or tacky craft glue for gluing down the foam
- Masonite board, tempered on one side or matboard cut to size 4¼" x 6"(11cm×15cm) for a backing for your mold. Use the uncolored side of the matboard.
- Ballpoint pen for drawing your design on the foam. The ink will not come off on the wet paper.
- Scissors

For Making Paper

- Old kitchen food blender or processor for grinding up the paper pulp
- Cotton linter to use as a base for your pulp. Linter comes in large sheets from an art supply store. One sheet will make a great deal of cast paper for a few dollars. The alternative to linter is to use old watercolor paper or similar long-fibered paper, tear it into postage stamp-sized bits, soak overnight in water and then blend the torn pieces.
- Acrylite panel or a smooth formica countertop as a base for couching off the paper (receiving the freshly-made paper)
- Screen and deckle set for papermaking (see side bar)
- Rectangular dishpan
- Smooth cloth (piece of an old sheet or utility wipe) about 6"×8" (15cm×20cm) to place on your acrylite to receive the paper
- Large, cloth towel to put under your countertop to absorb water when couching paper

For Decorating and Mounting Your Dry Casting

- Watercolor pencils and an atomizer (spray bottle) or
- Watercolor paint and small brush or
- Several colors of inks or liquid watercolors in atomizers for spraying the castings. This can be used with or without stencils for an all-over effect.
- Gold paper or metallic fabric paint for accents on any of the above
- YES glue or tacky craft glue for mounting
- Half dozen clothespins to hold your casting in place while the glue dries. Use bits of paper to pad the pin clamps so they do not leave marks.
- Light-colored wax crayon for picking up and gluing tiny bits of accent paper
- Gold paper or fancy paper

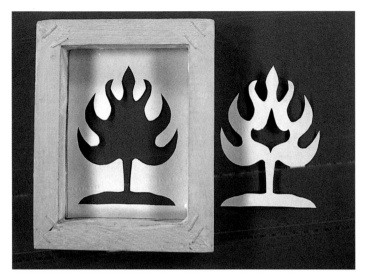

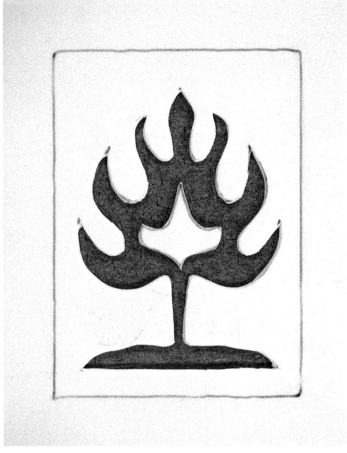

1 | Design Your Deckle

Trace the inside shape of your deckle onto several pieces of paper so you can try several designs. Allow a bit of space at the edges of your design. For your first casting, choose a subject that has a definite outside shape. Sketch or free cut your design out of the paper. "Drawing" lightly with your scissors will help you to make a more lively composition, so do try plunging in without a sketch. Try several ideas.

Next, with a ballpoint pen trace the inside shape of your deckle onto your sheet of foam. This will enable you to place your design in the space gracefully. If your design has been cut out, arrange the paper on the foam and trace around it with your pen. If you have not cut out your design yet, then scribble on the back of your paper with a very soft lead pencil (such as 6B) to make "carbon paper" and trace over your design with a pen to transfer it onto the foam.

Keep your inside and outside shapes intact. Instead of stabbing into your foam to cut out your design, just cut in from one edge until you meet up with your drawing. Then continue cutting all the way around it. Your first cut into the border can be glued together when you mount your foam and will hardly show at all. Look at the middle shape of your design and decide if you want to cut another shape or shapes out of it.

2 | To Reverse or Not to Reverse

Decide whether or not you need to consider reversing your design. If it is symmetrical (the same on both sides), like my tree of life, then it will cast as you see it. If it is not symmetrical, and you want it to cast as you designed it, turn all the pieces of your foam over when you glue them down.

Apply your tacky craft glue very carefully with a brush, first to your outside shape. On your piece of board place your outside border foam shape and bring your starting cuts together. Then glue in your inside pieces if you have them. Look to see if any bits of glue are showing on your mold and wipe them off with a damp cotton swab or cloth. Bits of leftover glue may cause your paper to stick and tear when you cast. Wrap your mold in waxed paper and put it under a press, such as a heavy book, to dry.

1 | **Equipment and Supplies**
Tear the cotton linter into pieces about 2-inches (5cm) square and let them soak in water for half an hour. You can always strain, dry and recycle what is left over, so be a bit generous. Your paper will be about half as thick as the original linter, so use this as a guide for how much to use for the number of cards you are planning to make.

Fill your blender about three-fourths full of tepid water and add a small handful of soaked linter. Blend for about 15 seconds. If you blend it too long you will cut the fibers into short pieces and they will not mat together well. Pour the blended pulp into a dishpan. Continue making pulp until you have about a 3-inch (8cm) depth of water and pulp floating in the dishpan.

Wet the utility wipe and lay it flat on your smooth plastic surface. Stir the pulp with your hand to get the fibers floating. Set down your screen with the screen side up. Place the deckle on top of the screen. Use both hands to pick up the screen and deckle and hold them together. You are going to form your sheet of paper on the screen inside the deckle frame. Holding your screen and deckle vertically, stretch your arms out in front of you and lower them into the pulp. Once under the pulp, turn the screen and deckle flat (horizontal). Gather an even layer of paper fibers as you bring them toward you and up to the surface of the pulp. If your paper sheet looks too uneven, rinse off the paper, stir the pulp and start again.

Tip your screen and deckle to drain the excess water back into the dishpan. You may have to wipe off some fibers from the top of the deckle.

2 | **Check for Holes**
Look at your sheet to make sure that it is fairly even and has no very thin spots or big lumps. The paper will look quite thick, which is what you want.

3 | **Remove the Deckle**
The high edges will mat down to form your deckle edge on the paper.

Tip Pulp will clog your sink. Always dispose of the leftover pulp outside.

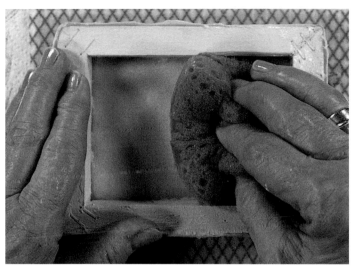

Couch Your Paper

4 | The freshly made sheet of paper will stick to the screen so that you can turn it over and place it down on the utility cloth. Sponge inside of the screen, pressing down to remove water from the paper and to mat the fibers together. Keep wringing out your sponge and soaking up the water until the paper is not oozing water any more.

Release the Paper

5 | Press down on one edge of your screen with your thumb. With your other hand snap the screen up away from the paper. The screen should release from the paper and leave the newly formed sheet of paper on the utility cloth.

Move onto the Mold

6 | Leave your paper clinging to the utility cloth and position it on your mold according to the lines you have drawn as a border.

7 | **Press Your Paper into the Mold**
Lay a dry cloth over the utility cloth. Press with your fingers to remove water from the paper and to bend the paper fibers into your foam design. Repeat until the paper feels damp, not soggy. Remove the utility cloth, cover the cast paper again with a dry cloth and press out a bit more moisture. Remove your casting once you can see the design clearly showing.

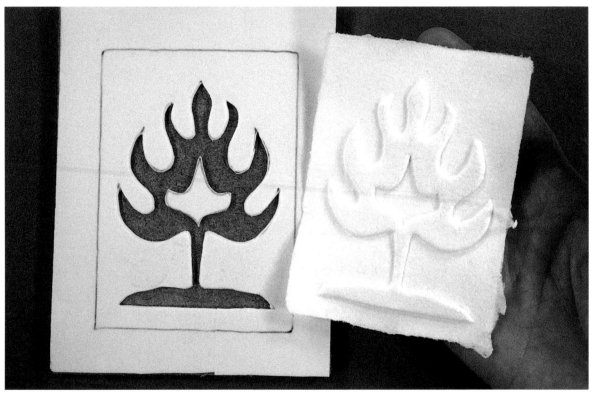

8 | **Lift Your Casting From the Mold**
With your fingernail, carefully tickle a corner up and gently lift the casting from the mold. Lay it to dry on a flat surface.

Embellish Your Cast Paper

Some people enjoy the beauty of plain white cast paper. However, if you want to add accents to your dry piece, there are several alternatives and I'm sure you will discover more.

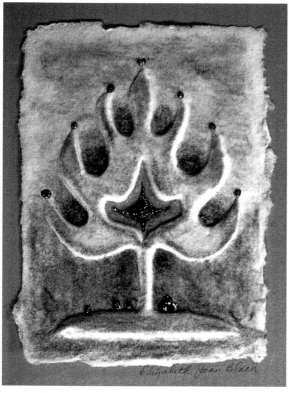

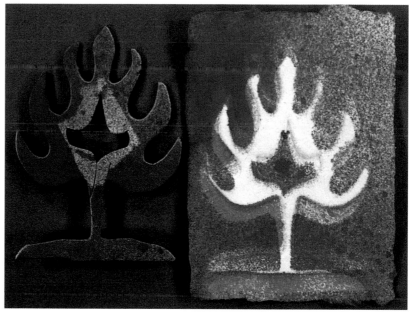

Watercolor Pencils and an Atomizer

Once you casting has dried thoroughly, apply color gently with the pencil held flat for raised edges and on end for recessed areas. Start with lighter colors and blend as you move to darker colors. Spray your casting lightly with an atomizer to pop out the colors and bring out their intensity. Add touches of gold with fabric paint.

Cut-Out Stencil and Spray on Color

Atomizers tend to drip and spatter so try out yours first on scrap paper. Usually the cast paper will absorb and blend in any large droplets. Try various types of inks and liquid watercolors. Atomizers usually need to be held upright to function, so set up your dry casting at an angle. Use pins to hold it in place inside a large cardboard box and spray it outdoors. You might consider using your cut-out piece as a stencil if you can prop or pin it in place. Experiment to see what will work for you. It is hard to get an exact line, but you can get a soft effect with the sprayers and some attractive blends.

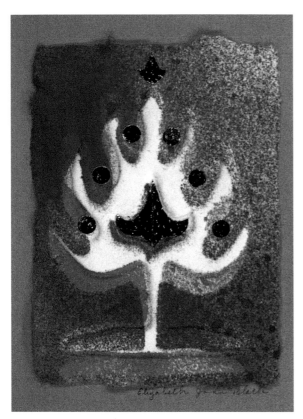

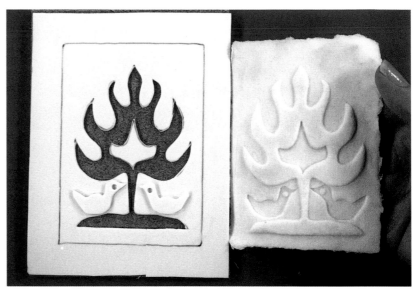

Foam-on-Foam
Notice what happens in the casting when you glue some little birds onto the foam under the tree. The deeply recessed effect make the birds appear to be sitting right under the tree.

Accents of Gold Paper
Bits of gold paper punched or cut out and glued on will add richness to your piece. Using a toothpick or a pin, place a tiny drop of glue where you want to place your little piece of gold paper. Press the point of a light-colored wax crayon on the top of the gold piece. The paper will cling to the crayon and you can press the paper into place without getting your fingers in the glue. Press the gold paper down all over with the end of a paint brush handle to give a beaten gold effect.

Tip If you want tiny dots or lines of gold, fabric paint in a pointed-tip container is likely easier to handle.

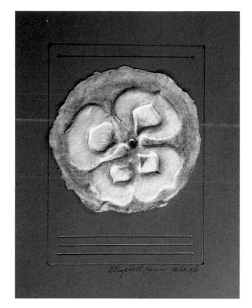

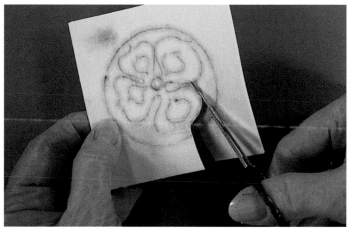

Embroidery Hoops or Small Scissors
A 3-inch (8cm) round embroidery hoop will give you a small paper cast that will easily fit on a card. For more intricate cuts on smaller designs, manicure scissors are handy.

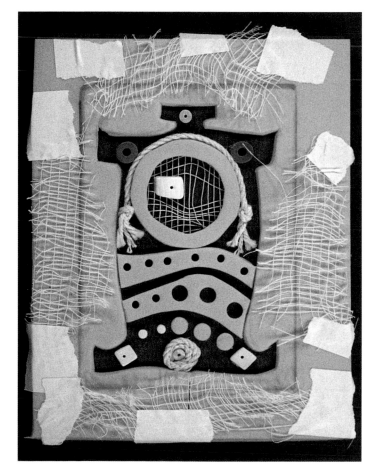

Found Objects
Button, beads, mesh and cords glued to your background can add interesting touches.

Mount Your Casting
To prevent clamp marks on your composition (as it dries), pad the clothespins with pieces of cardboard or foam. You will not want to put this art in a press!

Experiment! Experiment! Experiment!
Try many kinds of decorations on your cast paper to give variety and interest. The first piece was colored with watercolor pencils and sprayed with water. The second was colored with watercolor paint. The edge was painted with intense paint, then just inside the intense painted edge, water was brushed on to give a graduated effect.

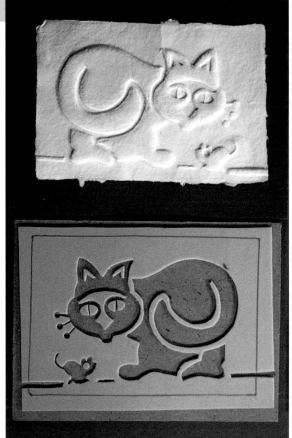

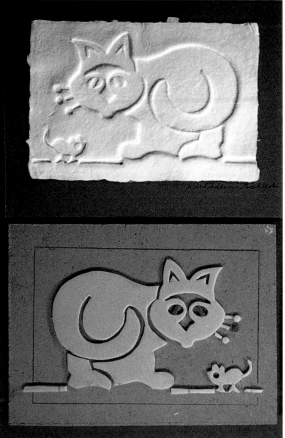

Kathy Schiewe used very small scissors and a tiny round punch to make her mold. Thanks to careful cutting she could use both the positive and negative images of her subject.

CAT AND MOUSE • Kathy Schiewe • Paper cast using plastic foam, positive and negative images • 4$\frac{1}{4}$" × 5$\frac{1}{2}$" (11cm × 14cm)

Gallery

Inspired by one example of an exotic breed of chicken, Kathy Schiewe enjoyed letting her sense of humor shine in her lively paper cast.

THE FUNKY CHICKEN • Kathy Schiewe • Paper cast using plastic foam • $4^1/_4$" × $5^1/_2$" (11cm × 14cm)

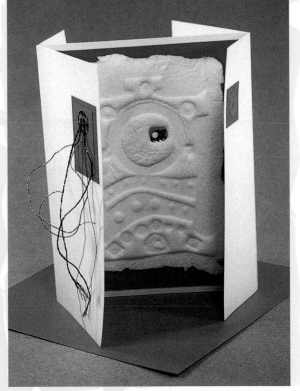

I have always liked the idea of horses being free and so I made my carousel horse break away from the merry-go-round of life.

RUNAWAY CAROUSEL • Elizabeth Joan Black • Paper cast colored with watercolor pencils • $4^1/_4$" × $5^1/_2$" (11cm × 14cm)

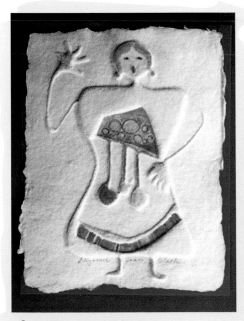

After a trip to New Mexico I became intrigued by the drawings of the ancient tribes of the area. I enjoy making variations on the singer theme.

ANCIENT SINGER II • Elizabeth Joan Black • Paper cast, watercolor pencil • $5^1/_2$" × $4^1/_4$" (14cm × 11cm)

On the other side of this card is the tree of life casting with the two little birds. I made the icon-like figure a golden door for its heart. I saw that the two pieces might be related by words. I wrote a tiny poem to bind the pieces together that reads:

Enter into
The doorway of my heart —
Together we will share
The tree of life.

INVITATION • Elizabeth Joan Black • Paper cast, gold paper, threads mounted in a double doorway fold • $5^1/_2$" × $4^1/_4$" (14cm × 11cm)

Conclusion

Now that you know how to do several techniques for designing greeting cards, and I'm sure have invented some new ones of your own, here are some suggestions about ways to have fun with your cards:

⊚

Decorate your envelopes to match your card or to complement the stamp on the envelope. Your work will cheer many people along the way, especially if your letter goes to a patient in hospital.

⊚

Contact your post office's philatelic center to receive information on forthcoming stamp issues. In the United States, the center is in Philadelphia, Pennsylvania. Call 1-800-STAMP-24. In Canada it is in Antigonish, Nova Scotia. Phone 1-800-565-4362. In order to obtain the most interesting stamps you must usually order from the philatelic centers. Check the Internet for more information.

⊚

Send "back and forth cards." You make the background, the recipient adds to the design and returns it. You add words or more details. Keep on until you are satisfied, then start a new card.

⊚

Share your card-making skills with your children, grandchildren and friends. Get together to make cards—have a card party.

⊚

Visit your local printer or copy shop and request some cover stock off-cuts to play with.

⊚

Make a set of a half dozen or so cards and envelopes, add interesting postage stamps and a colored pen for a useful gift for a housebound senior or your hostess. Sometimes I label these packages "Do It Write Now!"

⊚

Make up a quantity of cards, decorate the envelopes, stamp them and put on your return address label. Keep them handy for writing quick notes.

⊚

You will have a feeling of accomplishment when you write the notes you know you should and do it on time. Just a few written words of thanks or concern can lift someone's spirits many times over. Who can you thank today for some recent or long-past kindness that has changed your life for the better? Sharing your very personal artistic work and your heartfelt words with someone else will bring you joy—and that I believe is fun of the deepest kind.

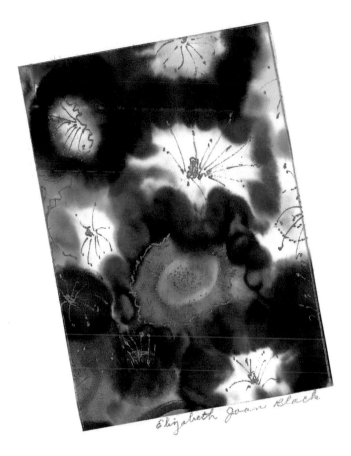

MORNING GLORIES • Elizabeth Joan Black • Watercolor markers, gold pen, bleach solution on Sumi-e paper • 5$^{1}/_{2}$" × 4$^{1}/_{4}$" (14cm × 11cm)

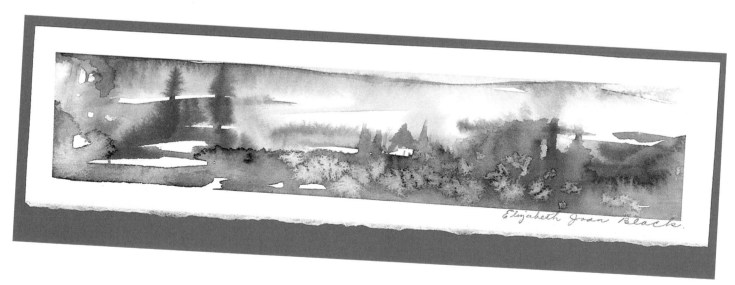

NORTHERN PASSAGE • Elizabeth Joan Black • Watercolor on 90-lb. (190gsm) hot-pressed watercolor paper • 2$^{3}/_{4}$" × 8$^{1}/_{2}$" (7cm × 22cm)

Index

Explore watercolor painting with North Light Books!

Infuse your watercolor florals with drama and intimacy! These five step-by-step demonstrations and easy-to-follow instructions show you how to capture nature's beauty up close. You'll learn how to mingle colors, manipulate light and design dynamic compositions. It's all the information you need to portray stunning, close-focus flowers with confidence and style.

ISBN 0-89134-947-2, HARDCOVER, 128 PAGES, #31604-K

Beautifully illustrated and superbly written, this wonderful guide is perfect for watercolorists of all skill levels! Gordon MacKenzie distills over thirty years of teaching experience into dozens of painting tricks and techniques that cover everything from key concepts, such as composition, color and value, to fine details, including washes, masking and more.

ISBN 0-89134-946-4, HARDCOVER, 144 PAGES, #31443-K

Traditional Chinese watercolors capture the essence of natural objects with a profound, unmatched beauty. Renowned artist Lian Quan Zhen shows you how to paint in this loose, liberating style through a series of exciting, easy-to-follow demonstrations. You'll learn how to work with rice paper and bamboo brushes, then master basic Chinese brushstrokes and compositions principles.

ISBN 1-58180-000-2, HARDCOVER, 144 PAGES, #31658-K

There are two paths to good composition: the hard way (cross your fingers and hope for the best) and the easy way (use the simple techniques in this book). Make things easy on yourself and get all the instruction you need to build strong, engaging compositions every time!

ISBN 0-89134-891-3, HARDCOVER, 128 PAGES, #31379-K

Check out these other great North Light titles!

Learn how to act upon your artistic inspirations and appreciate the creative process! This book shows you how to express yourself no matter what unusual approach your creations call for! Experiment with and explore your favorite medium through dozens of step-by-step mini demos. Start today and make your artistic dreams a reality!

ISBN 1-58180-102-5, HARDCOVER, 144 PAGES, #31790-K

Stop wasting time searching through books and magazines for good reference photos only to find them out of focus, poorly lit or lacking important details. In this book, you'll find over 500 gorgeous reference photos of forty-nine different flowers. Arranged alphabetically, each one comes with a variety of close-up and detail shots.

ISBN 0-89134-811-5, HARDCOVER, 144 PAGES, #31122-K

Inside this incredible reference you'll find more than 1,000 definitions and descriptions—every art term, technique and material used by the practicing artist. Packed with hundreds of photos, paintings, mini-demos, black & white diagrams and drawings, it's the most comprehensive and visually explicit artist's reference available.

ISBN 1-58180-023-1, PAPERBACK, 512 PAGES, #31677-K

Claudia Nice introduces you to the joys of keeping a sketchbook journal, along with advice and encouragement for keeping your own. Exactly what goes in your journal is up to you. Sketch quickly or paint with care. Write about what you see. The choice is yours—and the memories you'll preserve will last a lifetime.

ISBN 1-58180-044-4, HARDCOVER, 128 PAGES, #31912-K